IMAGES
of America

BLOCK ISLAND

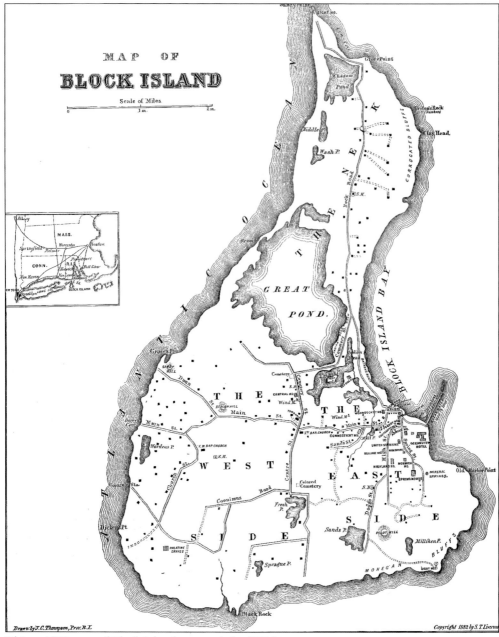

This *c*. 1882 map of Block Island was made by S.T. Livemore.

Cover Photograph: Henry Littlefield (far right) and his friends are aboard his fishing boat, the *Madilene*, in 1934. (From the Sandy L. Strickland Collection.)

IMAGES
of America

BLOCK ISLAND

Donald A. D'Amato
and Henry A.L. Brown

ARCADIA
PUBLISHING

Published by Arcadia Publishing
Charleston SC, Chicago IL, Portsmouth NH, San Francisco CA

Printed in the United States of America

Library of Congress Catalog Card Number: 2005926134

For all general information contact Arcadia Publishing at:
Telephone 843-853-2070
Fax 843-853-0044
E-mail sales@arcadiapublishing.com
For customer service and orders:
Toll-Free 1-888-313-2665

Visit us on the Internet at www.arcadiapublishing.com

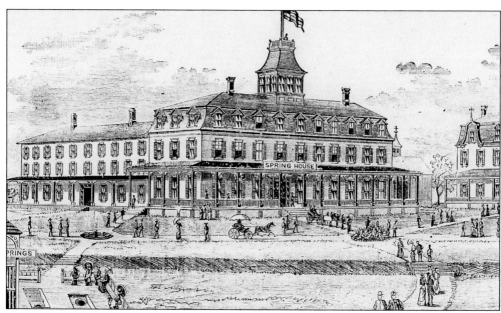

From the cupola and the broad piazza of the Spring House in the 1870s, the beach, the ships entering the harbor, and many other points of interest can be seen.

CONTENTS

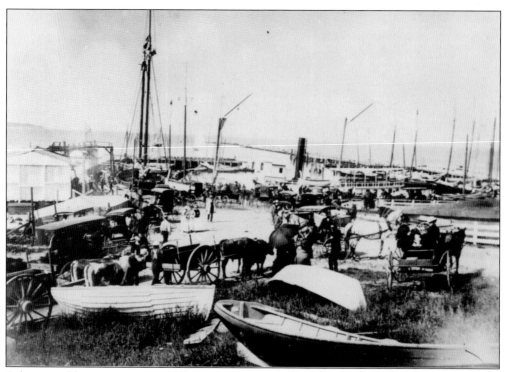

A horse and buggy, ox-carts, and wagons gather at Old Harbor, c. 1885, awaiting the steamer from the mainland. The Old Harbor dock was essential in making Block Island a vacationer's paradise and enhancing the lives of the islanders. (From the Sandy L. Strickland Collection.)

ACKNOWLEDGMENTS

Henry and Don would like to express their thanks to those who have been so helpful in putting this book together. Nothing would have been possible without the assistance and generosity of many "on-islanders" and former islanders. In addition to having Henry's collection of postal cards and photographs, we have been fortunate to obtain material from Sandy L. Strickland and Nicholas De Petrillo. We are indebted to them as well as to all historians, photographers, and contributors who have written about and who love the island.

Ann E. Brown deserves special thanks for her patience, tolerance, and assistance. Whatever literary merit this volume may have is due in a great part to the efforts of Jean D'Amato, whose editing, proofreading, and persistence are, as always, greatly appreciated.

INTRODUCTION

Circled by waters that never freeze,
Beaten by billow and swept by breeze,
Lieth the Island of Manisses.
—John Greenleaf Whittier

One of the state of Rhode Island's greatest treasures is Block Island with its sandy beaches and thundering surf. The island, 7 miles long and 3.5 miles wide, was known to the Narragansett Indians as Manisses (Little God's) Island. It lies in the Atlantic, between Point Judith, Rhode Island, and Montauk Point, New York.

Block Island, or New Shoreham as it is also known, is far enough from any mainland to have developed a history of its own. Its past is laced with fascinating accounts of greed-induced warfare, dastardly pirates and privateers, heroic resistance to tyranny, and self-sacrificing attempts to rescue vessels cruelly battered near the island's rock-infested shoal waters.

At any time of the year, Block Island has a special look and charm of its own. In addition to the rolling hills and fertile valleys, the island has an estimated 365 ponds, puddles, and sinkholes—one for every day of the year. Block Island also has great clay cliffs that rise to a height of 150 feet, while Beacon Hill in the central part of the island rises to a height of 234 feet.

In addition to the scenery and summer climate, Block Island presents one of the most fascinating dichotomies found in Rhode Island. During the summer months, its harbors are full of pleasure craft, its hotels teem with tourists, and the population soars upward of 7,000. In sharp contrast, the winter population is a sparse 500, boats are few, and even the Block Island Ferry, the island's primary contact with the mainland, often does not make the trip.

The island's history also presents us with an interesting study of data exclusive to the island. The written history begins in 1524, when Giovanni Verazzano, an Italian navigator sailing for the king of France, first discovered the pear-shaped island. No Europeans landed there until 1614, when a Dutch navigator, Adrian Block, landed the small ship *Unrest* on the shores of the island that would later bear his name.

For the next 200 years, the history of the island seemed to coincide with the name of Block's ship, for the Colonial Period was largely tumultuous and chaotic. In 1636, soldiers from Massachusetts invaded Block Island, destroyed the power of the Manisses Indians, and claimed the area as their own. By 1660, the island was sold to 16 proprietors and the history of Block Island as part of Rhode Island began. When Block Island became a town in 1692, the charter read, "the town of New Shoreham, otherwise Block Island."

During the early 18th century, there were very few permanent settlers, as life was difficult and raids by privateers and pirates were common. During the French and Indian War, inhabitants of the island were terrorized by French privateers, who resorted to killing and torturing the

inhabitants in their quest for riches. Captain Thomas Paine of Jamestown eventually drove the pirates from the island.

When the hostilities between England and the colonies began in 1775, Block Island found itself a target for deserters and criminals, as well as for British raids. It was during the 18th century that practically all the trees on the island were used for fuel or building purposes. Fortunately, the Block Island ponds contained a great deal of peat, which became the primary source of fuel well into the 19th century.

The main occupations for the islanders during the early years were farming and fishing. The sea around the island is rich in fish and is today one of the reasons many come to the island. The seas, however, can be treacherous, and Block Island has had its share of wrecks and tragedies over the centuries. Two of the most often cited shipwrecks are the *Palatine* tragedy of 1752 and the sinking of the *Larchmont* in 1907.

It was not until the late 19th century that Block Island developed into a significant summer resort. The reason it was so delayed was the lack of a good harbor. Attempts were made as early as 1680 to develop the Great Salt Pond into a suitable mooring for large vessels. The early settlers formed a harbor company to keep a breach open to the sea. This was successful for 14 years, but repeated failures afterward saw the project abandoned in 1707.

Because of the lack of a good natural harbor, the people of Block Island developed their own type of sailing vessel, often called "double enders" or "cowhorns." These ships sit deep in the water and have proved to be extraordinarily seaworthy. In 1813, fishermen on the island constructed Pole Harbor by sinking 20-foot oak poles 6 feet deep at the end of Crescent Beach (where Old Harbor is now). The number of poles eventually grew to over 1,000.

In 1867, Nicholas Ball and others received funds from the federal government to construct the island's first deepwater harbor. It was completed in 1872 and was called New Government Harbor, later known as Old Harbor. By 1887, thanks to the efforts of Christopher (Kit) Champlin, funds were obtained to cut a channel from Great Salt Pond and to dredge it. This undertaking, now known as New Harbor, was completed in 1899.

With two excellent harbors, Block Island began to attract a lively trade. It promised a "healthy sea-voyage without the discomfort prevalent in ocean-going vessels" of the time. During the late 19th and early 20th centuries, steamers from New York, Connecticut, and Rhode Island arrived daily in the summer with thousands of passengers. One of the highlights of this period was when President Ulysses S. Grant visited the island on August 18, 1875.

In the period following World War I, the resort industry declined and several of Block Island's most fashionable hotels closed. For a while, the island became self-supporting again through fishing and farming. However, during the period following World War II, the charm of Block Island again captured the public's imagination, and it has developed into one of the most desirable summer vacation sites in the Northeast.

Henry A.L. Brown and Donald A. D'Amato, through postcards and photographs, have tried to capture some of the nostalgia as well as the spirit that prevails on the island today.

One

OLD HARBOR

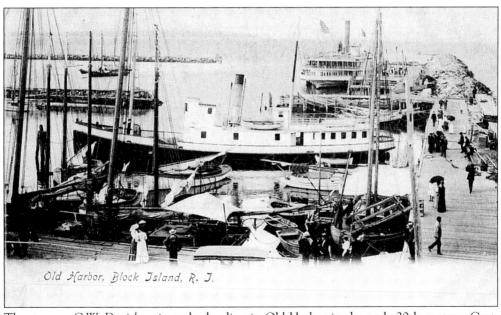

Old Harbor, Block Island, R. I.

The steamer G.W. *Danielson* is at the landing in Old Harbor in the early 20th century. Capt. Martin Van Buren Ball was the owner of the G.W. *Danielson*, which carried the mail to Block Island from Newport for 25 years. (From the Henry A.L. Brown Collection.)

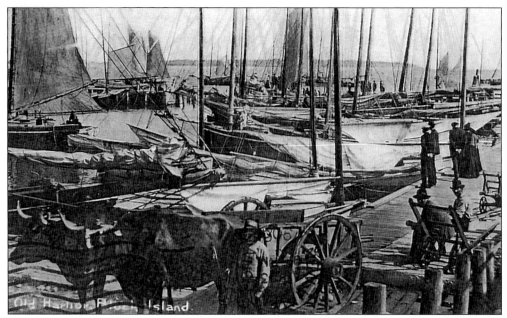

Teams of oxen performed many duties on old Block Island, from hauling seaweed from the slippery shore, to being on-hand for the heavy freight in the late 19th century. For many decades, the sure-footed oxen were more popular for this type of work than the horses, and were a common sight on the island. (From the Henry A.L. Brown Collection.)

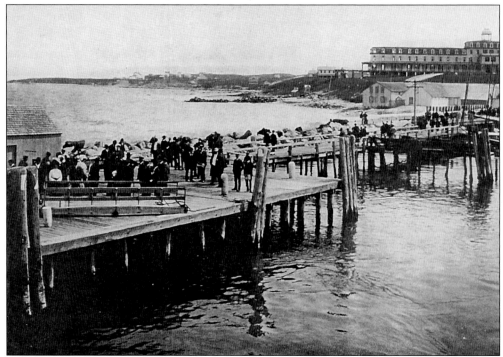

Large groups gather at the Old Harbor dock eagerly awaiting the ferry arriving with needed supplies. Once the Old (or Government) Harbor was created, supplies, as well as paying guests, could come to the island in great abundance. (From the Henry A.L. Brown Collection.)

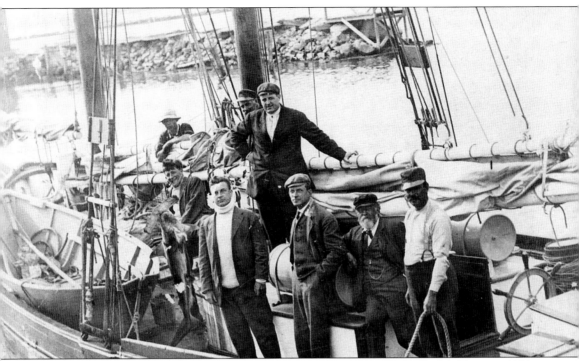

Henry Littlefield (far right) and his friends are aboard his fishing boat, the *Madilene*, in 1934. The group was about to leave Old Harbor in pursuit of a sensational trip, hopefully resulting in a catch of fish. This sturdy vessel survived the Hurricane of 1938. (From the Sandy L. Strickland Collection.)

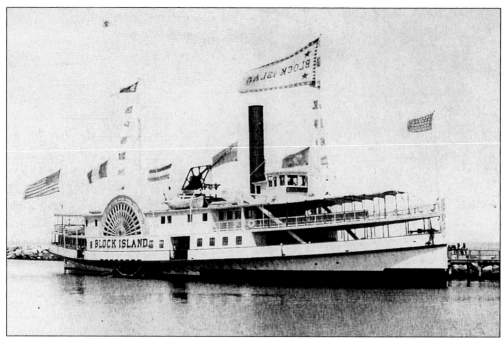

The Age of Steam brought many fine vessels to New Shoreham. This one, the *Block Island,* was one of the finest of the day. (From the Henry A.L. Brown Collection.)

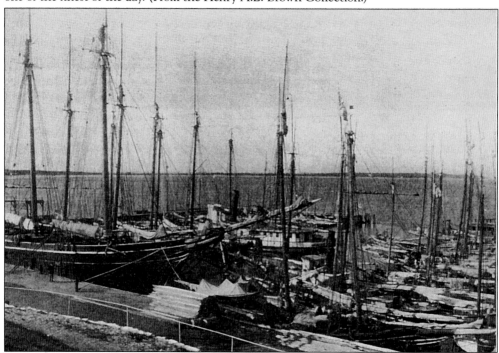

During the Age of Sail, the basin was resplendent with masts silhouetted against the horizon. Many of these were fishing vessels that plied the seas during the Civil War, when fish from the island brought high prices. A "quintal" (a bundle weighing 112 pounds) sold for $10.55 during that period. (From the Henry A.L. Brown Collection.)

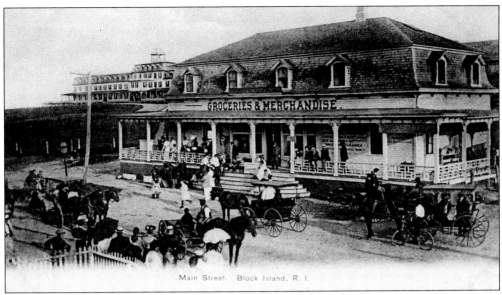

Main Street, now Water Street, appears complete with horse-drawn wagons; this scene was common when the 19th century was giving way to the 20th. Cassius Clay Ball's store can be seen here. This is where bartering was the order of the day on the "cash-poor" island. (From the Henry A.L. Brown Collection.)

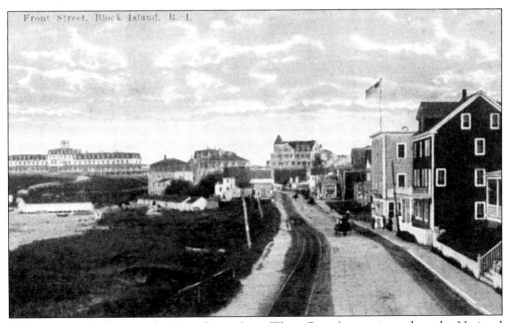

This photograph shows early Main Street (now Water Street) at a time when the National Hotel was the most fashionable summer place for politicians and the "in-crowd." (From the Henry A.L. Brown Collection.)

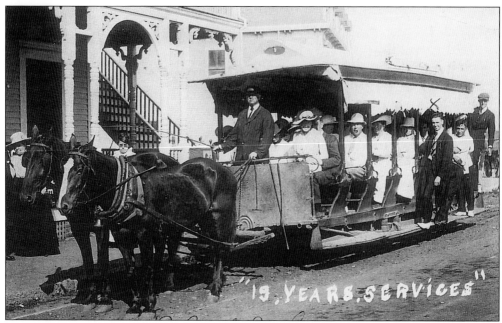

Mary Geers tells us that her uncle can be seen on this horse-car, which made its way on Block Island in 1911. The vehicle is stopped before the Cassius Clay Ball House, "Harbour Cottage," at the major intersection at Old Harbor. The horse-car was used each summer for 15 years and ran between Old Harbor, Crescent Beach, and New Harbor. (From the Henry A.L. Brown Collection.)

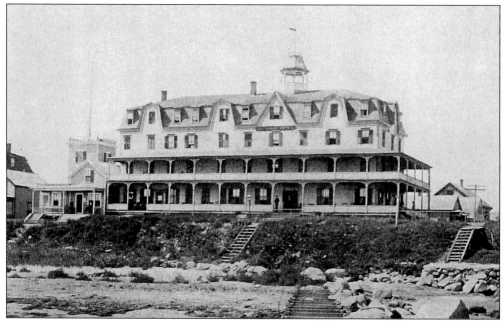

The New National House, built in 1903 by Frank Hays, was one of Block Island's most famous hotels at the turn of the century. Guests were able to descend from the hotel to the beach via a wooden set of stairs. This 20th-century structure replaced the 1888 house that burned in 1902. (From the Henry A.L. Brown Collection.)

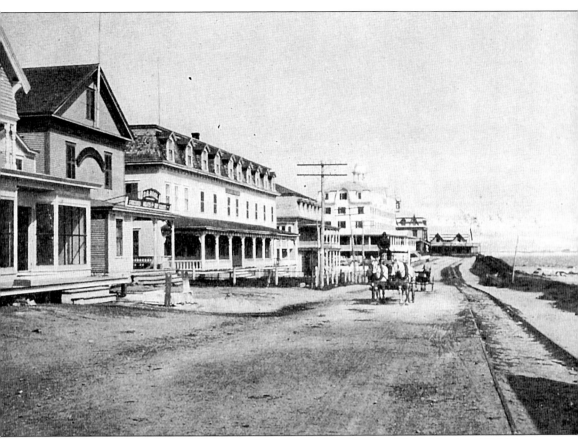

A handsome team of white horses leads the way down Main Street on Block Island, in 1894. Note the horse-car tracks. This was the beginning of the period when quick, efficient transportation (for the era) came with the nostalgic Block Island Electric Trolley, which horses powered, not electricity. (From the Henry A.L. Brown Collection.)

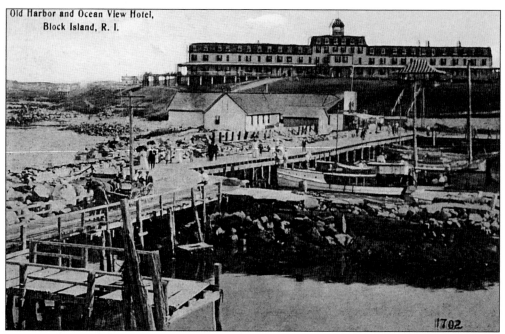

Old Harbor and Ocean View Hotel, Block Island, R. I.

Departing "day-trippers" had time for a sumptuous clam bake at Berber's Bake House, shown in the foreground. This was one of the many special attractions on the island. (From the Henry A.L. Brown Collection.)

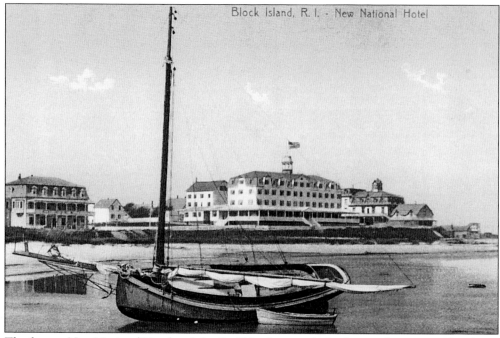

Block Island, R. I. - New National Hotel

The famous New National Hotel and the Surf Hotel are in the background as a moored catboat, grounded at low tide, awaits its owner in 1913. (From the Henry A.L. Brown Collection.)

16

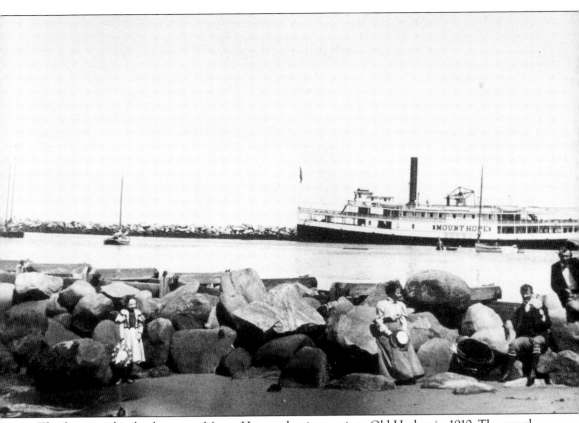

The famous side-wheel steamer *Mount Hope* makes its way into Old Harbor in 1910. The vessel was built in Chelsea, Massachusetts, in 1888, and had its last run in 1934. It was the main link to Block Island for nearly half a century. (From the Henry A.L. Brown Collection.)

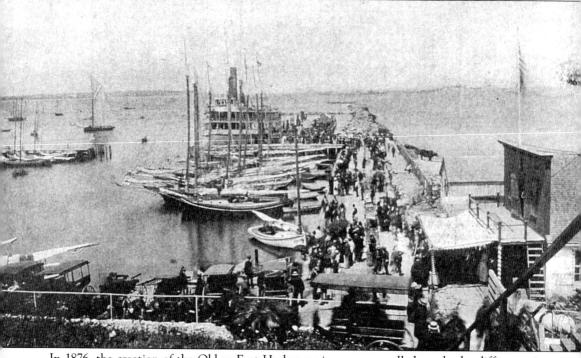

In 1876, the creation of the Old or East Harbor, as it was once called, made the difference in transforming Block Island from an attraction primarily for fishermen to a major recreational area. Prior to the harbor, no decked vessel could land at the island, severely curtailing steamboats with many passengers. Note the carriages waiting at the dock. Each hotel sent its own vehicle for its patrons. (From the Henry A.L. Brown Collection.)

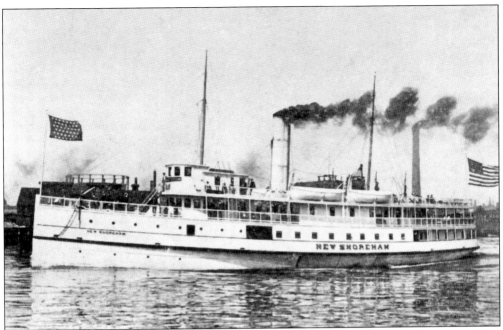

In 1915, the Block Island, Newport, and Providence Steamboat Company's steamer *New Shoreham* was celebrated for its fast and safe transportation of goods and people from Newport to Block Island. The steamer left Newport at 9 a.m. on weekdays and arrived at the island in mid-morning. (From the Henry A.L. Brown Collection.)

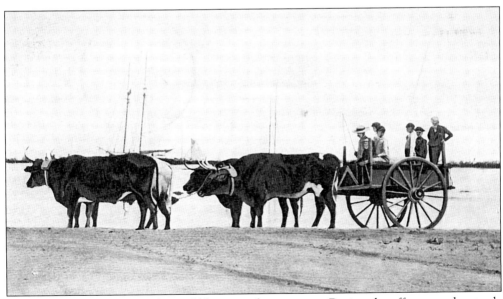

To say the oxen were versatile would be an understatement. During the off-season, the sturdy animals pulled cartloads of tourists rather than the customary seaweed or cargo. (From the Henry A.L. Brown Collection.)

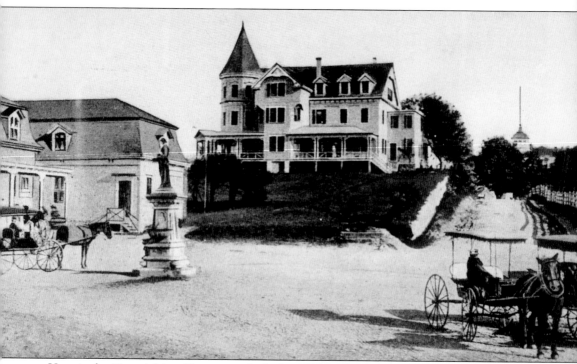

Here is the New Adrian House as it looked in 1906. The first "public house," or hotel, was opened on this site in 1842. At that early date, however, the island had not yet become a major resort, as it was before the building of Old Harbor. Rebecca, the temperance statue, faces C.C. Ball's Harbor House. (From the Henry A.L. Brown Collection.)

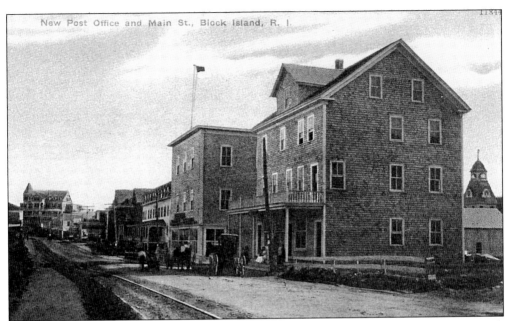

One of the most significant meeting places on the island in the 1930s was, as might be expected, the post office. Mail, which had to be brought in by boat, was eagerly awaited by all. The post office is no longer on this site. It has been moved to a new building, which overlooks the ferry dock at Old Harbor. (From the Sandy L. Strickland Collection.)

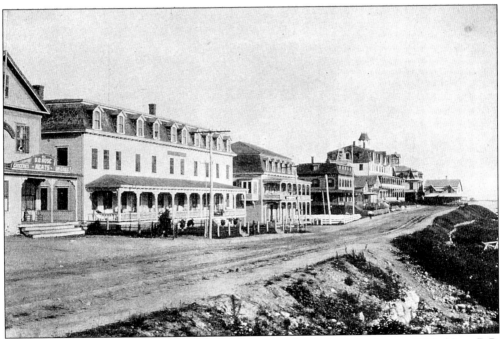

This fine array of hotels has been captured by an island photographer, c. 1912. Note D.B. Rose's grocery store on the far left, next to the Pequot House. (From the Henry A.L. Brown Collection.)

21

Block Island's first automobile came on the scene when C.C. Ball decided to bring the modern vehicle to the island. Mr. Ball registered this Cadillac, plate #62, in July 1904, on the first day of registration for motor vehicles. (From the *Block Island Scrapbook*, by Maizie, 1957.)

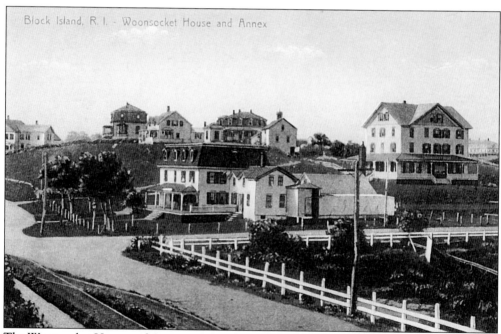

The Woonsocket House and Annex was another of the very popular Block Island summer hotels. The Woonsocket House was formerly the Gideon Rose House, built in 1820. It was enlarged in 1871 and began to take in boarders. It has been the home of the Block Island Historical Society since the mid-1940s. (From the Henry A.L. Brown Collection.)

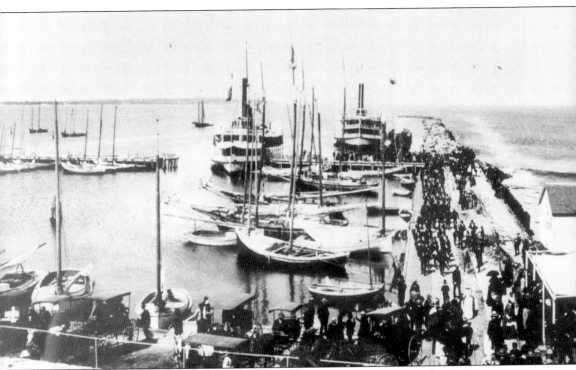

In the late 19th century, Civil War veterans enjoyed a reunion at Block Island. These troops marched along the pier at the Old Harbor. They were the Third Rhode Island Artillery and were joined by Generals Ambrose Burnside and Elisha Hunt Rhodes. (From the Henry A.L. Brown Collection.)

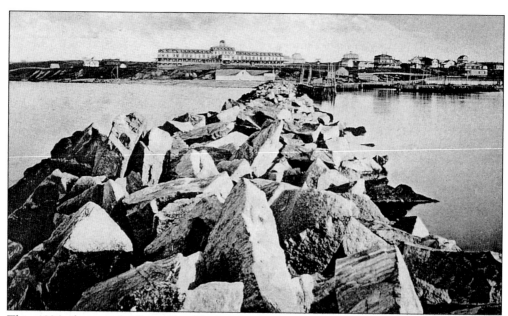

This 1896 photograph shows the Block Island Harbor, which was made possible when F. Hopkinson Smith constructed a breakwater in 1876. Ninety-three tons of stone were used, and the cost of the structure totaled $155,000. (From the Henry A.L. Brown Collection.)

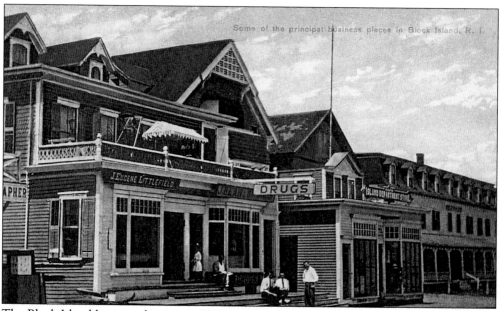

The Block Island business district, in 1911, presented a nice small-town façade, appreciated by early 20th-century visitors from the big cities who were trying to get away from it all. (From the Henry A.L. Brown Collection.)

Two men, patiently sitting on their handcart, await the arrival of freight in 1906. During the early part of the 20th century, steamers were able to carry the large amount of supplies needed for the island's growing economy. (From the Henry A.L. Brown Collection.)

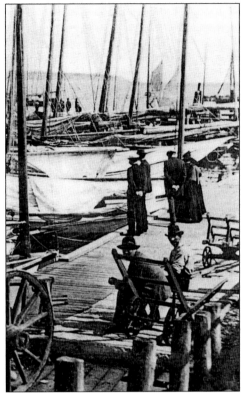

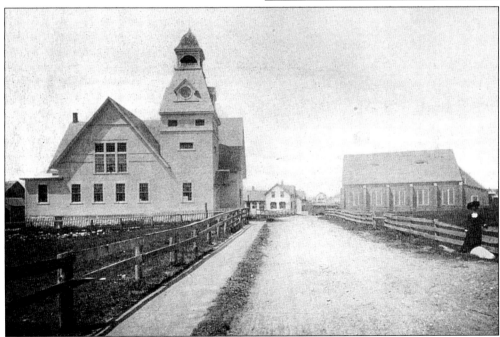

Notice how the old Baptist church looked, c. 1904–08. The church burned c. 1940, and the congregation moved to the Adrian House at Fountain Square at Old Harbor. (From the Henry A.L. Brown Collection.)

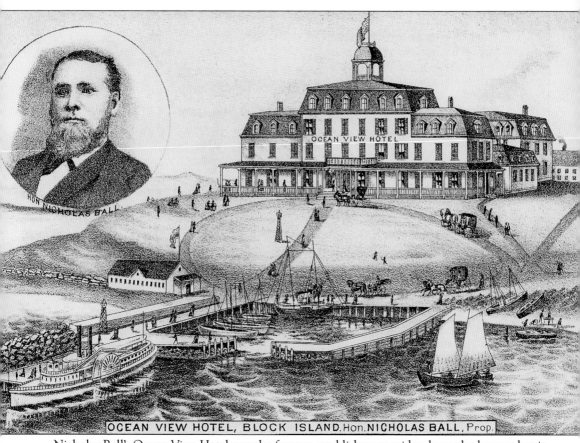

OCEAN VIEW HOTEL, BLOCK ISLAND. Hon. NICHOLAS BALL, Prop.

Nicholas Ball's Ocean View Hotel was the famous establishment said to have the longest bar in the world. It once played host to President U.S. Grant. At one time, the U.S. Supreme Court was in attendance here as well. Ball built the hotel in 1873. Unfortunately, the lovely historic structure burned in 1966. (From the Henry A.L. Brown Collection.)

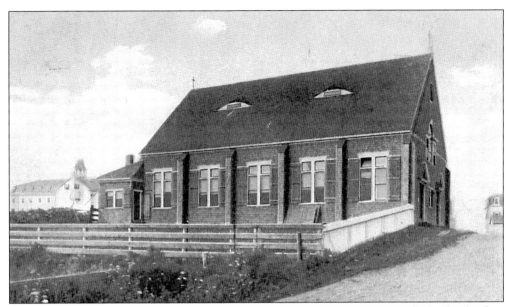

By the close of the 19th century, large numbers of Catholics were coming to Block Island to live and to visit. Consequently, St. Andrew's Roman Catholic Church was built to accommodate their needs. The building was brought to the island in sections and assembled on Chapel Street. (From the Henry A.L. Brown Collection.)

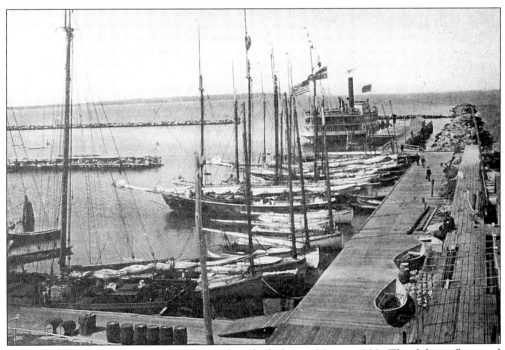

These sailing vessels graced the Old Harbor dock from 1904 to 1908. The fishing fleet and catboats were very popular during this period for sport fishing. This is the era when Block Island fishermen were known for their ability to harpoon the majestic swordfish. (From the Henry A.L. Brown Collection.)

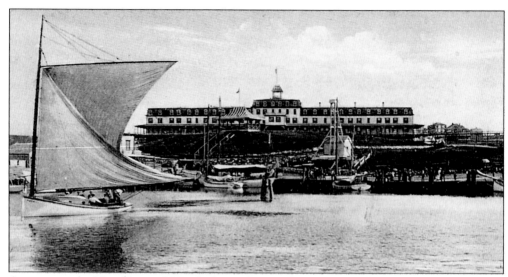

As it passes the New National Hotel, this catboat is dropping its sail after a pleasant morning cruise. At one time, catboats, many of them built in Pawtuxet, were common sights in the island waters. (From the Henry A.L. Brown Collection.)

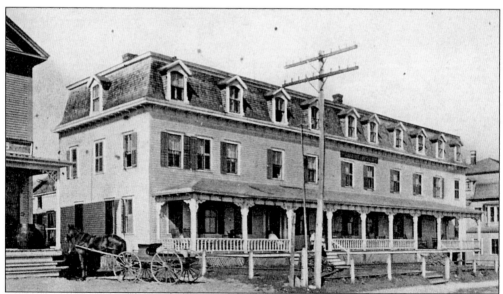

This photograph of the Pequot House, now the Harborside Inn, was taken c. 1906. The Pequot House, built in 1879, was once owned by Darius B. Dodge, a member of one of Block Island's families noted for its daring sea captains. By the 1890s, the establishment was operated by Thaddeus A. Ball. (From the Henry A.L. Brown Collection.)

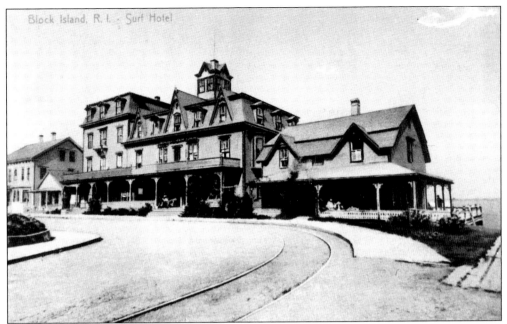

The Surf Hotel dates to 1873, with additions in 1884 and 1888. Its commanding site at the corner of Dodge and Water Streets has made it a familiar sight to all who come to the island. The popularity of Block Island as a desirable resort was emphasized on this 1910 card from a lady named Jennie to Bill Stott. Jennie commented, "This beats New York." (From the Henry A.L. Brown Collection.)

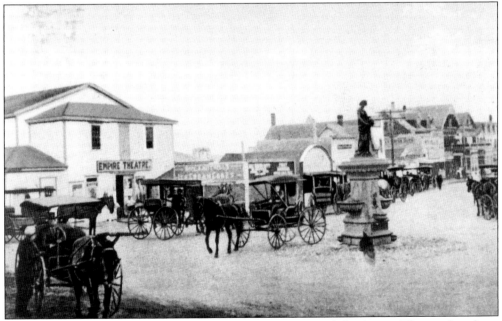

Fountain Square was a busy place in the late 19th century and the Empire Theater drew large crowds on rainy summer days. The theater, built in 1882, was once a roller skating rink. As the "movies" became more popular, it was converted into a center showing two films a night. (From the Henry A.L. Brown Collection.)

As a result of the increasing popularity of Block Island as a resort, some High Street homes became boardinghouses in the late 19th century.

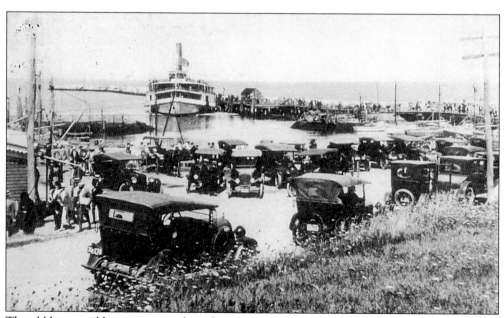

The old horse and buggy seems to have been replaced by a large array of motor vehicles seen at Old Harbor in the early 20th century. As elsewhere in America, many Block Islanders fell in love with the automobile. (From the Henry A.L. Brown Collection.)

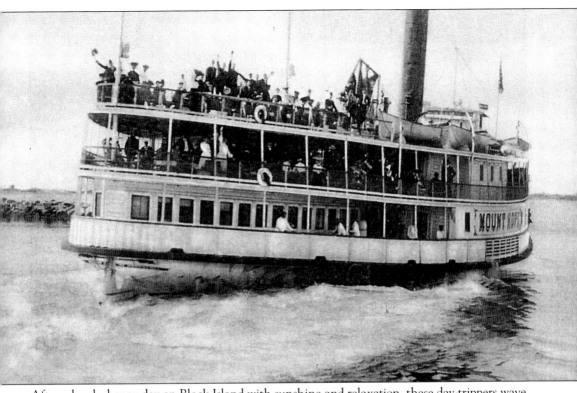

After a lovely, happy day on Block Island with sunshine and relaxation, these day-trippers wave from the *Mt. Hope* as it leaves Old Harbor. This joyous scene has been repeated countless times throughout the summer months as Block Island's popularity increased in the 20th century. (From the Henry A.L. Brown Collection.)

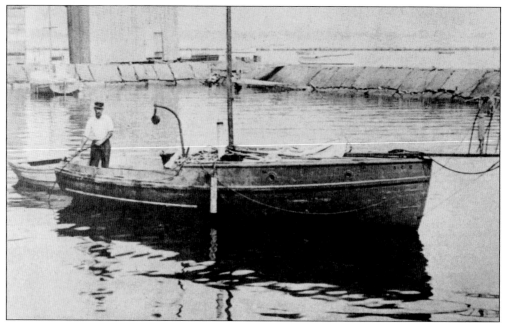

A very familiar sight in Block Island waters was the fishing vessel *I.C.U.* This ship and crew had just returned from the lobster fishing ground. Huge lobsters were often found off Block Island. In 1913, Col. Felix F. Wendelschaefer, well-known proprietor of the Providence Opera House, caught a 14.5-pound lobster while fishing for cod. (From the Sandy L. Strickland Collection.)

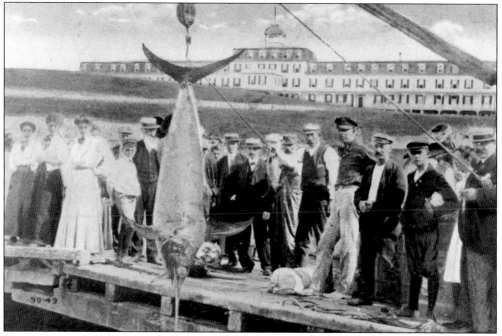

During the early 20th century, "off-islanders" (i.e. visitors) came to admire this 350-pound swordfish caught off Block Island. Ball's Ocean View Hotel, where many of the visitors stayed, is in the background. (From the Henry A.L. Brown Collection.)

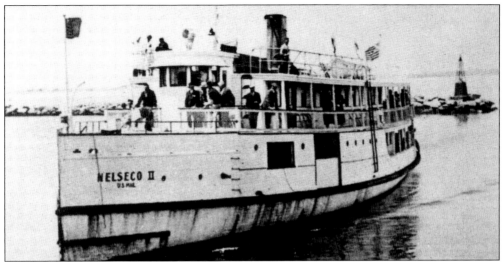

The *Nelseco II*, bringing the mail to the island, was often the main link between Block Islanders and their relatives on the mainland. Modern technology has made communication fast and simple now, but, for many years, the mail was the main channel for news. (From the Sandy L. Strickland Collection.)

When you go Fishing or Sailing, you will make no mistake if you Call on

CAPT. FRANK E. DODGE,

who has a Large, New Sail Boat

ALICE E. & BIRDIE.

Agent for all leading papers.

Residence Chapel Street, opposite Harbor Chapel.

FOR SAILING AND FISHING
THE PLEASURE BOAT **"SAY WHEN"**

CAPT. SILAS N. LITTLEFIELD,

Can be Chartered for Sailing and Fishing by the Hour, Day, or Week, at Reasoable Rates. NEW BOAT, EXPERIENCED BOATMAN GEAR AMD BAIT FREE.

If you wish to have Fresh and Salt
FISH PACKED.
Go Fishing or Sailing, be sure to call on
CAPT. H. F. WILLIS,
at his Fish Market.

Capt. Frank E. Dodge was one of Block Island's versatile captains. He fished in winter, took tourists in summer, and brought news to Block Island from the leading newspapers. (From the Henry A.L. Brown Collection.)

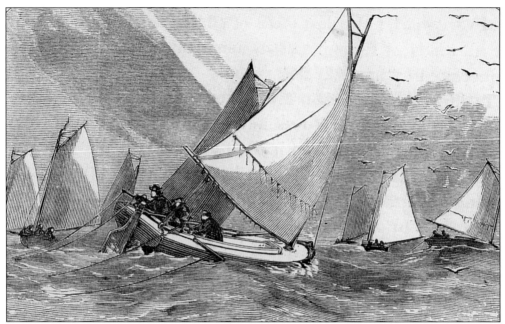

Block Island fishermen are depicted here trolling for bluefish. (From the Henry A.L. Brown Collection.)

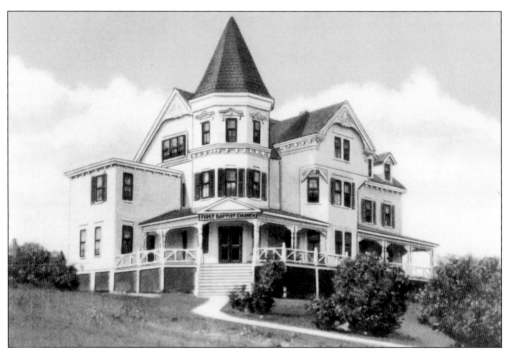

This very handsome Victorian structure, shown here as the First Baptist Church of Block Island, was formerly the Adrian Hotel, built in 1887. It is located on a commanding site overlooking the square at Water Street not far from the ferry boat landing. The church moved to this building in 1940, after its earlier structure burned. (From the Henry A.L. Brown Collection.)

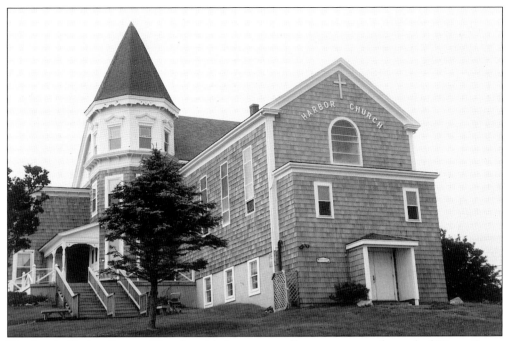

The lovely Harbor Baptist Church, with its commanding presence at the end of Water Street near Old Harbor, has taken an active part in the needs of the Block Island community in both the summer season and during the rest of the year. In addition to church services, various meetings are held here to improve the quality of life on the island. The building was formerly the Adrian Hotel and the First Baptist Church. (From the Don D'Amato Collection.)

When the Royal Hotel was owned by Helen K. McKiernan and managed by Malcolm Williams, this advertisement for the hotel noted that there was "dancing and entertainment nightly" and that the hotel was close to the beach. These were alluring words for anyone looking for a perfect place for a summer vacation. (From the Henry A.L. Brown Collection.)

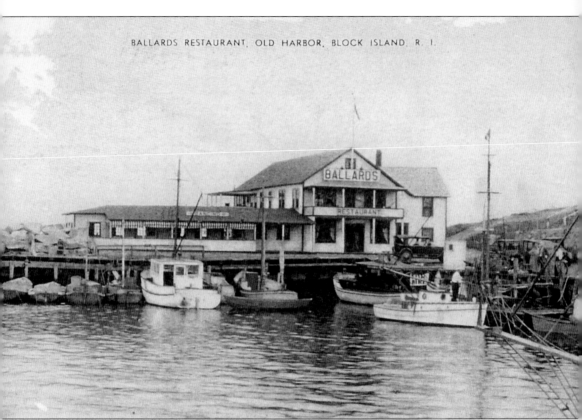

BALLARDS RESTAURANT, OLD HARBOR, BLOCK ISLAND, R. I.

Every visitor to Block Island knows Ballard's Restaurant and can remember the "bluefish special," as well as Dick Ballard's counting the glasses and Ma Ballard at the register. This photograph was taken c. 1928, ten years before the Hurricane of 1938 took its toll on the building. (From the Henry A.L. Brown Collection.)

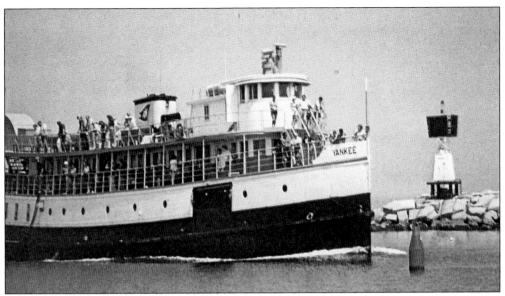

The *Yankee* brings day-trippers and freight from Providence and Newport in 1965. (From the Henry A.L. Brown Collection.)

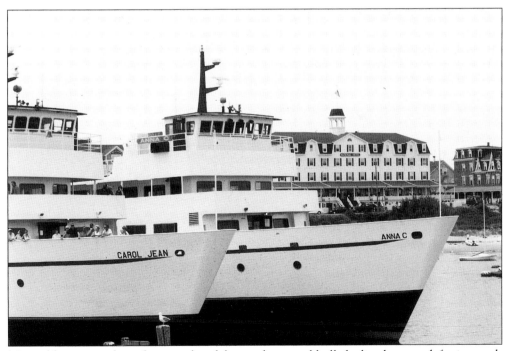

Most old steamers have been replaced by modern steel-hulled, diesel-powered ferries, such as the *Carol Jean* and the *Anna C.*, which now grace Old Harbor. (From the Don D'Amato Collection.)

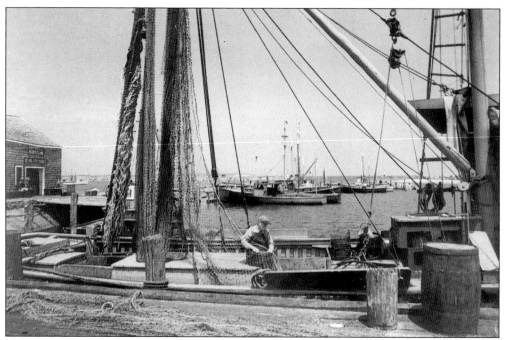

A fisherman is repairing his nets at the Old Harbor inner basin in 1972. (From the Henry A.L. Brown Collection.)

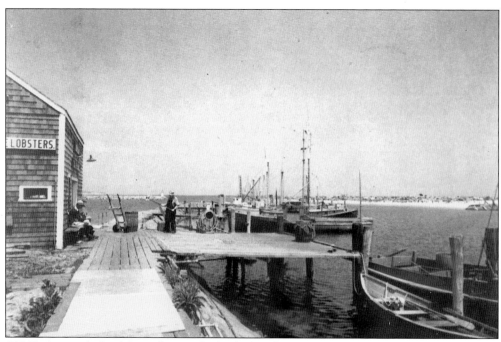

Old Harbor, with the fishing fleet in the background, greatly impressed an English woman who spent her summer vacation in New England. A highlight of her trip was a visit to Providence and a four-day stay on Block Island in 1964. (From the Henry A.L. Brown Collection.)

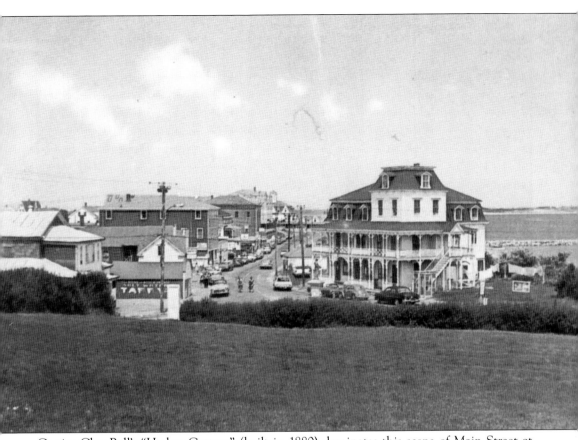

Cassius Clay Ball's "Harbor Cottage" (built in 1880) dominates this scene of Main Street at Old Harbor, c. 1970. Note the prominent three-and-one-half-story corner tower, added in 1887. For over a half-century Harbor Cottage housed the island's drugstore. (From the Henry A.L. Brown Collection.)

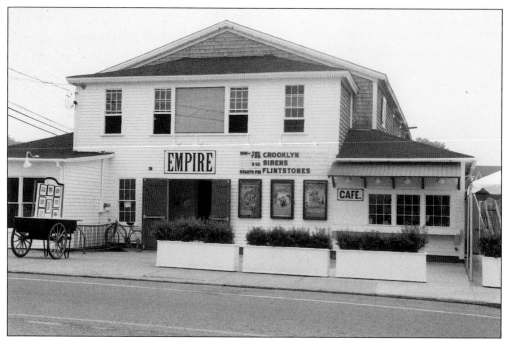

Anyone who has spent any length of time on Block Island surely remembers the Empire Theater on Water Street. The theater closed for awhile in the late 20th century and later re-opened in 1993. The building also houses a gallery and café. (From the Don D'Amato Collection.)

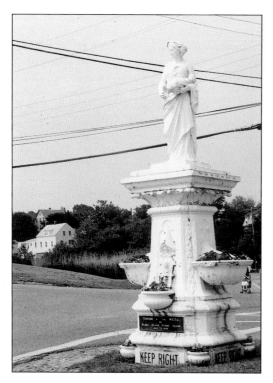

The statue of Rebecca, symbolizing a period when the Temperance Movement was strong on Block Island, continues to hold a dominant position on Water Street, not far from the church at Old Harbor. The Women's Christian Temperance Union erected it in 1896. The statue once featured a drinking spout for people and a watering trough for animals. (From the Don D'Amato Collection.)

King's Spa, owned by King O'Dell, was the island's foremost drugstore in 1970. This was the former C.C. Ball "Harbour Cottage," built *c.* 1880 and used as C.C.'s own residence at one time. (From the Henry A.L. Brown Collection.)

With the same type of anticipation as thousands of other visitors, Jean D'Amato eagerly awaits the docking of the ferry at Block Island on a beautiful summer day in July 1998. Like countless others, she loves Block Island as it was and as it is today. (From the Don D'Amato Collection.)

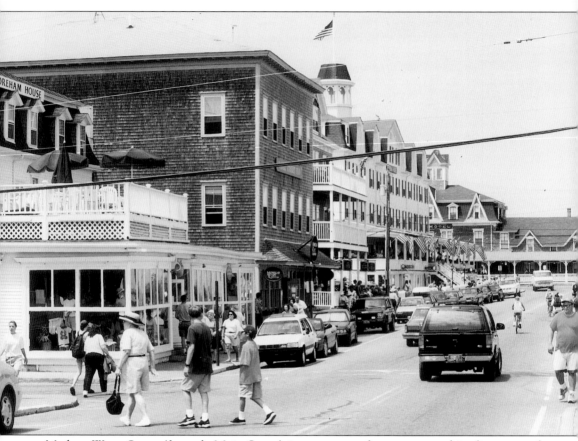

Modern Water Street (formerly Main Street) is a true waterfront street, and its fine array of stores and hotels are part of the island's charm. During the summer months, thousands fill the street, adding to the excitement and festive air the island evokes in both young and old. (From the Don D'Amato Collection.)

Two

CRESCENT BEACH AND NORTH LIGHT

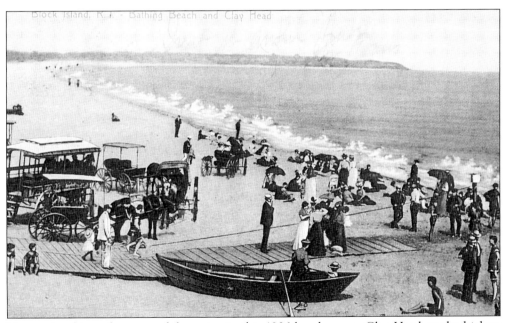

No one is taking advantage of the water in this 1906 beach scene. Clay Head, at the highest and most easterly point, can be seen in the background. Tradition states that no one can put up fences, even on private land, so that the beaches are accessible to all. (From the Henry A.L. Brown Collection.)

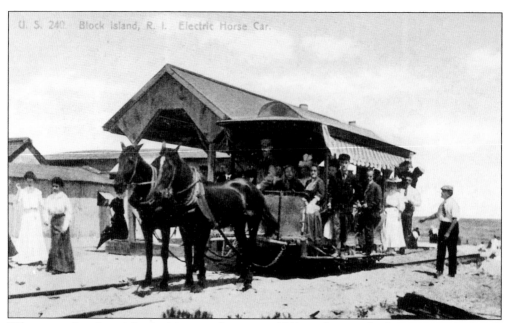

U. S. 240. Block Island, R. I. Electric Horse Car.

What great fun these island visitors are having in 1910, as they made their way to the beach via the famous Block Island horse-drawn trolley, humorously known as the "Electric Railway." Crescent Beach, free from stones and seaweed, stretches in a fine curve for nearly 2 miles. (From the Henry A.L. Brown Collection.)

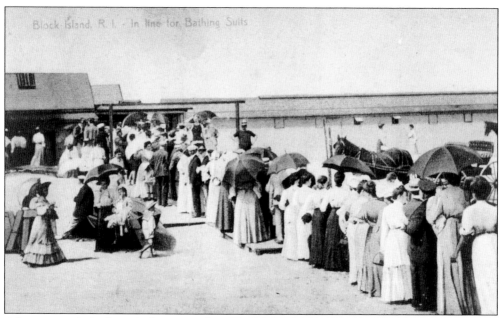

Block Island, R. I. - In line for Bathing Suits

A hot summer's day brought huge crowds to Block Island in the first decade of the 20th century. Here, a crowd waits in line to rent bathing suits. Once they left the bathhouse, they had a choice of swimming at State, Scotch, or Mansion Beach, all part of Crescent Beach. (From the Henry A.L. Brown Collection.)

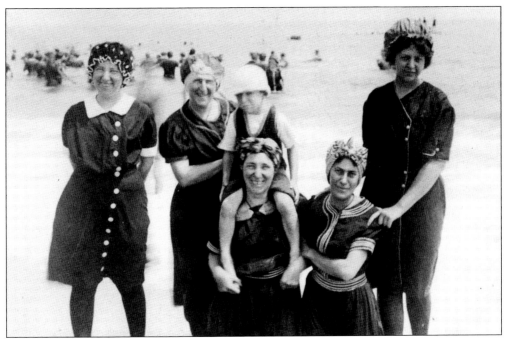

Wearing the latest in swim-wear fashion, this happy group of ladies consented to have their photograph taken in 1905. With its natural, unspoiled beauty, the beaches on the island provided an excellent escape from the complex life of the city. (From the Henry A.L. Brown Collection.)

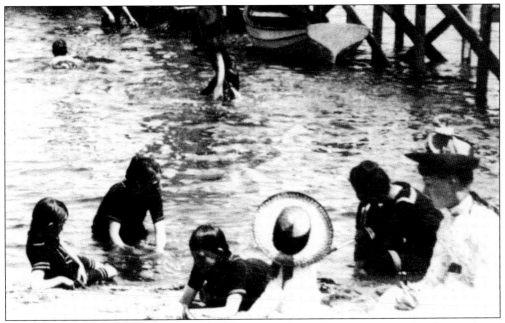

Children frolic and splash in this 1915 beach scene. Perhaps the vast ocean and endless grains of sand allow us to see how unimportant we are and so we are able to lose some of our inhibitions and enjoy having fun with nature. (From the Henry A.L. Brown Collection.)

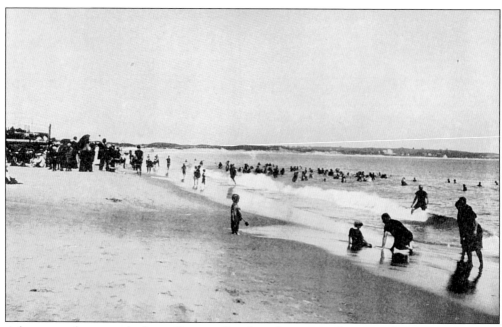

A large crowd came to bathe at Crescent Beach, to have a good time, and to enjoy one of the island's major attractions in the early 1900s. (From the Henry A.L. Brown Collection.)

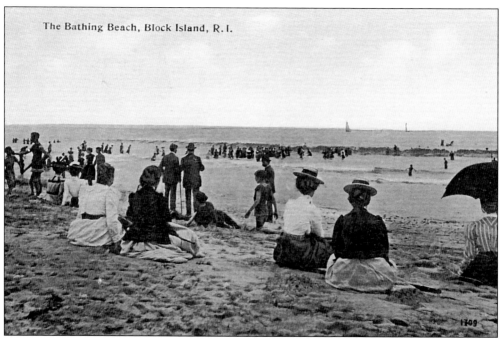

The Bathing Beach, Block Island, R.I.

Ladies sit on the beach, watching bathers on an especially hot day at the turn of the century. Straw hats and umbrellas shade the ladies from the strong sun. (From the Henry A.L. Brown Collection.)

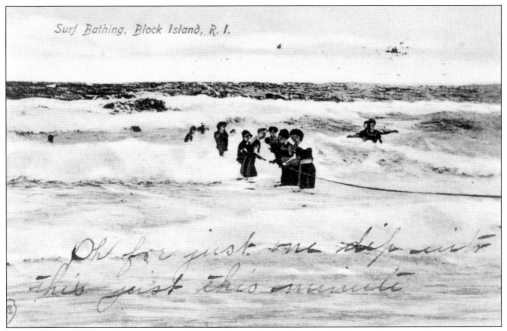

Surf Bathing, Block Island, R. I.

Oh for just one dip out this just this minute

A pounding surf can be a scary and dangerous place even for skilled swimmers. Here, a number of bathers in 1911 keep the line nearby, just in case. Days such as this were rare and usually occurred after serious storms. Over the centuries, these storms have leveled the beach to its present condition. (From the Henry A.L. Brown Collection.)

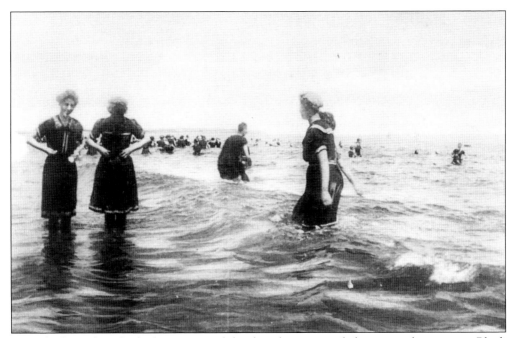

Properly dressed in the bathing attire of the day, these young ladies enjoy their visit to Block Island, *c.* 1909. Before the Gale of 1815, there was a line of sand dunes about 20 feet high along this section of beach. (From the Henry A.L. Brown Collection.)

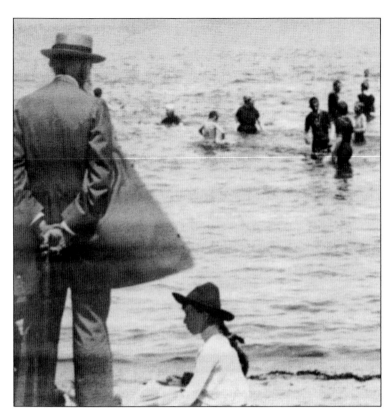

In the "good old days," if you were really fortunate, you got to spend a day at the beach on Block Island. An elderly gentleman enjoys watching the younger generation. (From the Henry A.L. Brown Collection.)

Everybody in the 1930s and '40s knew that the inner tube of the automobile tire was created for a better ride and was also an excellent flotation device. Silas Littlefield is getting his tube ready for a day at the beach. (From the Sandy L. Strickland Collection.)

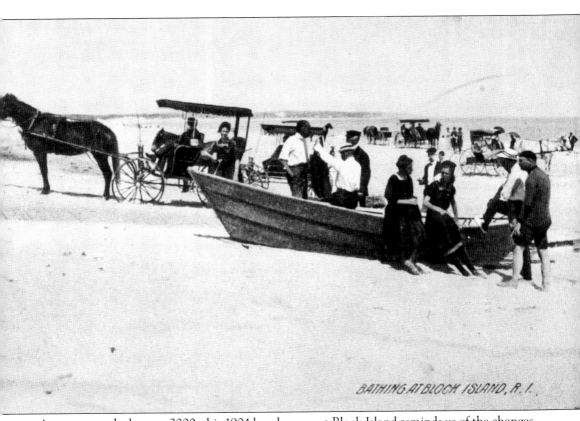

BATHING AT BLOCK ISLAND, R. I.

As we approach the year 2000, this 1904 beach scene at Block Island reminds us of the changes in transportation and beach attire that have taken place during the 20th century. (From the Henry A.L. Brown Collection.)

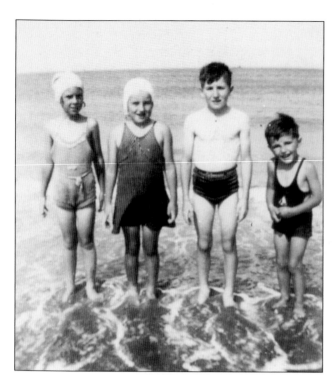

These kids stopped plunging into the surf just long enough to have their picture taken, c. 1939–40. The boys are members of the Anderson family. With scarcely any undertow and waves, the beach is ideal for children of all ages. (From the Sandy L. Strickland Collection.)

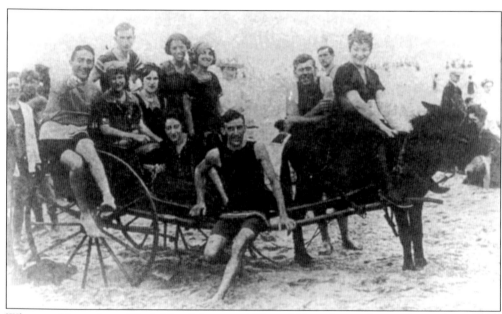

What could you do on Block Island that was different? How about ride on a burro-drawn (not horse-drawn) cart along the beach? (From Mynna M. Altman Collection.)

50

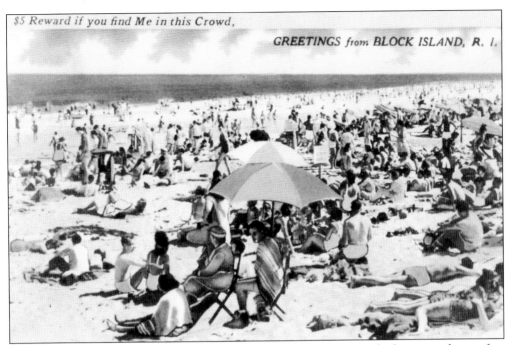

By 1955, beach attire had changed dramatically. By this point in time, the large crowds were free of the heavy, cumbersome suits that their grandparents took for granted. (From the Henry A.L. Brown Collection.)

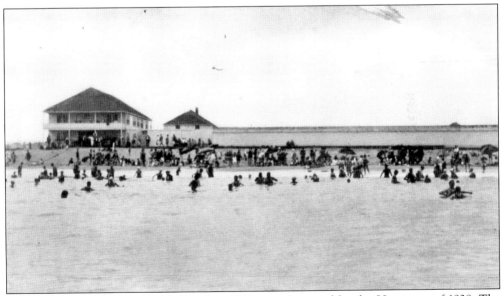

This bathing pavilion on Block Island, c. 1930, was destroyed by the Hurricane of 1938. The modern pavilion was built by the State of Rhode Island in 1954, providing modern facilities for the beach that rivaled those elsewhere in the state. (From the Henry A.L. Brown Collection.)

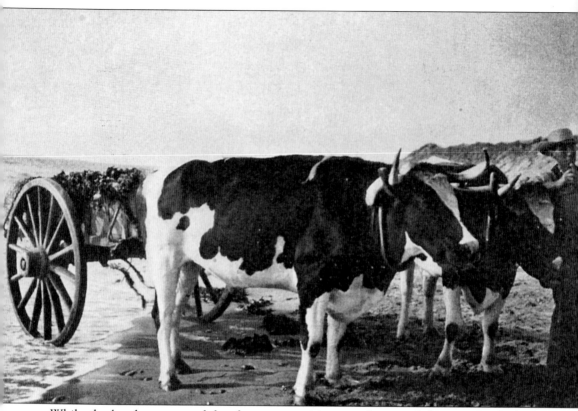

While the beach represented fun for summer visitors, it also provided seaweed, which the farmers used for fertilizer. These oxen, led by a boy with the ever-present switch, are ready to go home with the cart loaded with seaweed. Note the handsome wooden yoke. (From the Henry A.L. Brown Collection.)

A two-masted vessel, wrecked off Block Island, flounders on the shoals of the Block Island coast. Storms, fog, and a raging sea often brought disaster to vessels off the island well into the 20th century. (From the Henry A.L. Brown Collection.)

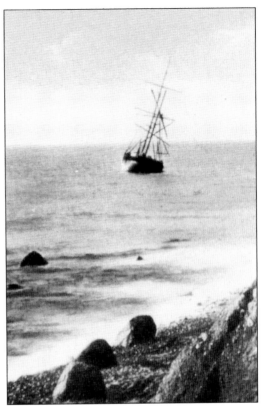

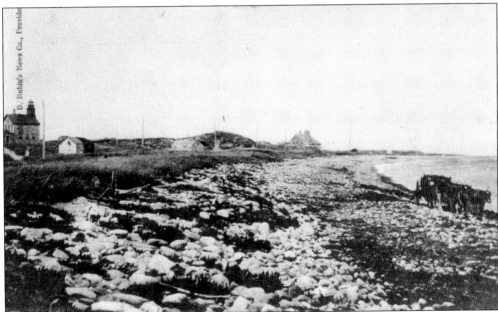

A farmer is using his ox-cart in the gathering of seaweed near the Sandy Point Life Saving Station early in the 20th century. Until the late 19th century, most Block Islanders were farmers, and the seaweed produced the main fertilizer that replenished the soil. (From the Henry A.L. Brown Collection.)

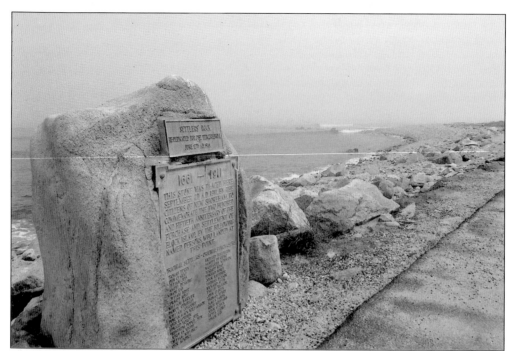

In 1911, the Settlers' Rock stone was dedicated to the original purchasers and settlers of Block Island to celebrate the 250th year of the settlement. (From the Don D'Amato Collection.)

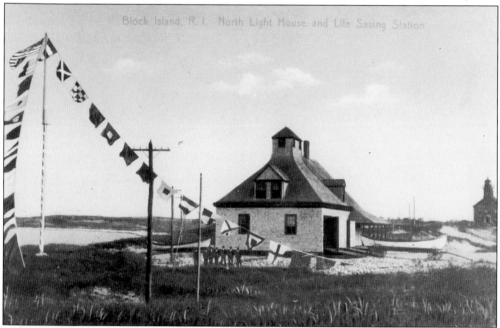

The Lifesaving Center, 1911, with the North Lighthouse off to the right reminds us of an earlier era on Block Island. For the last 70 years, efforts have been made by the state and the national government to make the waters off Sandy Point safer for mariners. This building was where the victims of the *Larchmont* were taken in 1907. The sea has since claimed the structure. (From the Henry A.L. Brown Collection.)

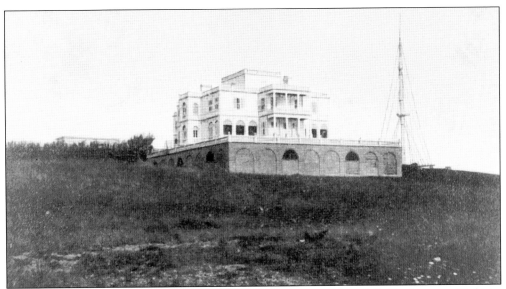

In the 1880s, one of Block Island's most affluent citizens, Edward F. Searles, a millionaire architect, built this terraced villa for his bride. Unfortunately, she died soon after the mansion was built, and Searles rarely visited the island after her death. In April 1963, the mansion burned to the ground. The spectacular fire could be seen from the mainland. (From the Henry A.L. Brown Collection.)

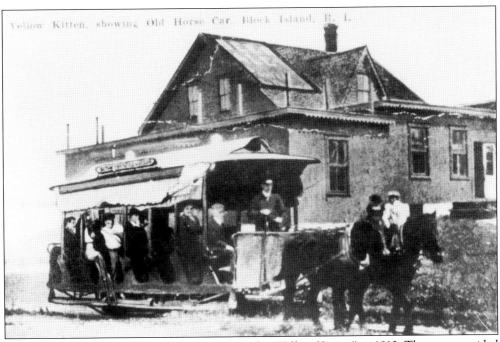

The slow-moving horse-car makes its way past the "Yellow Kitten," *c.* 1910. The cars provided a much quieter method of getting around the island than the modern, controversial moped. (From the Henry A.L. Brown Collection.)

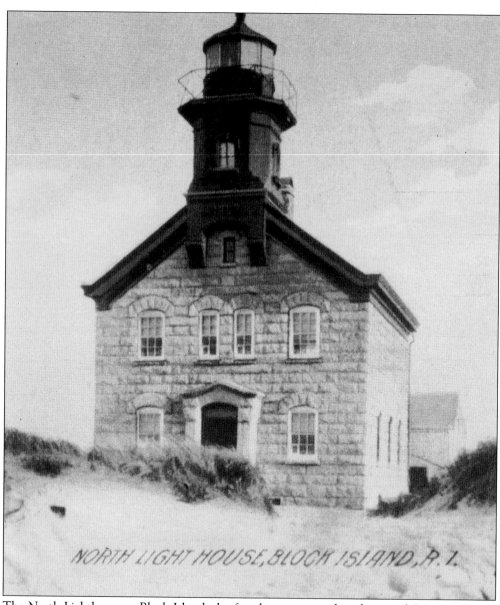

NORTH LIGHT HOUSE, BLOCK ISLAND, R. I.

The North Lighthouse at Block Island, the fourth one to stand at the tip of Corn Neck, was built of granite in 1867. Earlier lighthouses were built in 1829, 1837, and 1857. During a 38-year period, the shifting sand demolished all three. At one time, the keeper of the light lived at Sandy Point; however, since 1957, a flashing mechanism has taken the keeper's place. Thanks to federal funds, in 1993, the ground floor of the North Light became a museum. (From the Henry A.L. Brown Collection.)

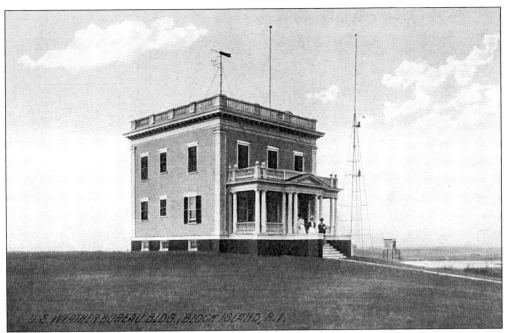

One of the most important structures on Block Island is this U.S. Weather Bureau building. The two-story station was built in 1903, replacing an earlier one, which burned in 1902. In 1950, the bureau moved to the airport and this building became a summer cottage. (From the Henry A.L. Brown Collection.)

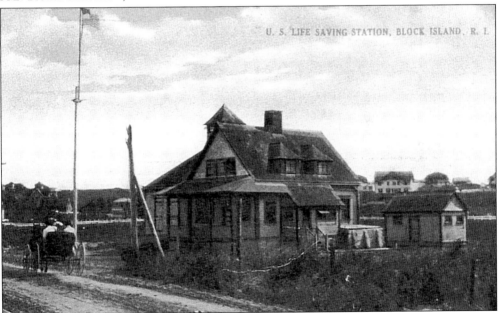

The U.S. Coast Guard (Life Saving Station) has played an important role in the history of Block Island. This photograph shows the station, c. 1906, when the most common mode of transportation on the island was the horse and buggy, and outhouses were at the rear of the building. The forerunner of this Life Saving Station was the one built on the island in 1874. (From the Henry A.L. Brown Collection.)

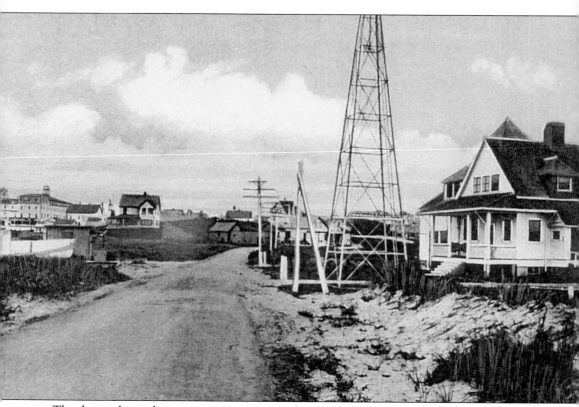

Thanks to this radio tower, communication became possible with the mainland. This was a far cry from 1872, when six island men patrolled the dunes every night from December to April. Note the 1911 jailhouse opposite the station. This early scene reflects the simple rural atmosphere of most of Block Island well into the 20th century. (From the Henry A.L. Brown Collection.)

Nicholas De Petrillo came to the beach to see the 40-foot whale carcass that washed ashore in 1976 at Crescent Beach. (From the Nicholas De Petrillo Collection.)

Everyone living on Block Island for any length of time has had at least some acquaintance with "The Exchange," as the town dump has been whimsically called over the years. Modern ordinances have made its use obsolete. (From the Henry A.L. Brown Collection.)

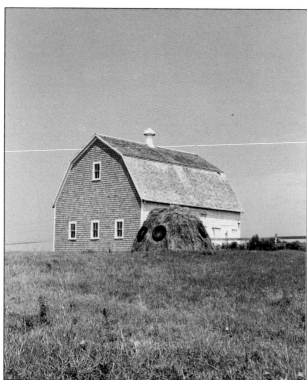

As we near the close of the 20th century, the number of farms on Block Island has decreased to the point where fewer and fewer scenic structures, such as Adrian Mitchell's barn, shown here in 1970, can be seen. (From the Henry A.L. Brown Collection.)

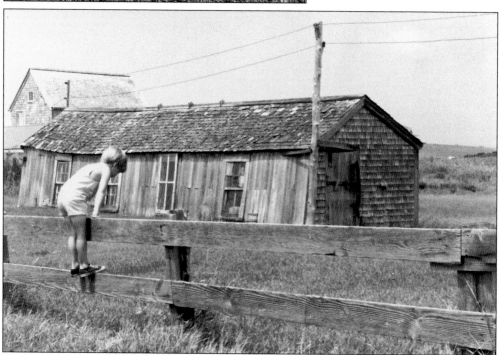

Billy Brown explores the area near an old fishing shanty across from Trimm's Pond in 1970. There always seems to be something for youngsters to do on Block Island during the summer months. (From the Henry A.L. Brown Collection.)

Three

THE CRUEL SEA
AND THE KIND SEA

Some hard-working fishermen take a smoke break near a shanty at Old Harbor, c. 1910–1915. In an earlier period, fish were carried through the sand to the fish houses. Obviously, this was very hard work. (From the Henry A.L. Brown (G.K. Page) Collection.)

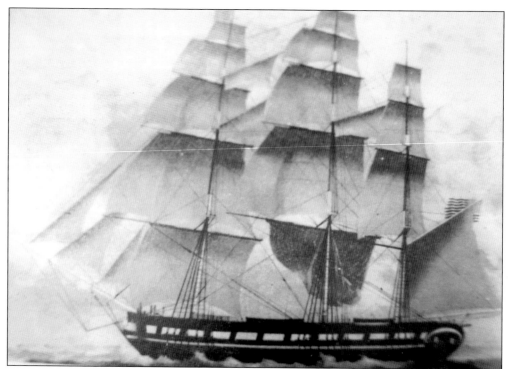

On January 10, 1806, during a blinding snowstorm, Brown & Ives' beautiful sailing ship, the *Ann & Hope*, under the command of Captain Laing, found the seas too rough and was wrecked off the Block Island coast. Not long after, Congress appropriated funds for a lighthouse on Block Island. (From the Henry A.L. Brown Collection.)

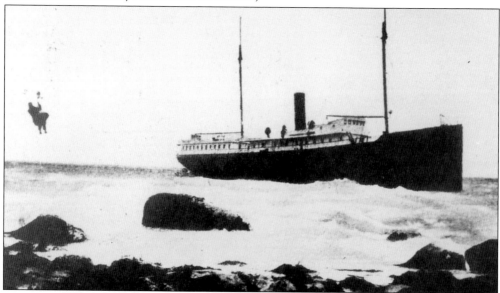

The beautiful sea can also be cruel, as this scene indicates. The good ship *Spartan* was wrecked off the east side of Block Island in 1905. Fortunately, many of the crew were lifted to safety with the use of the "Breeches Buoy," seen here on the left. (From the Sandy L. Strickland Collection.)

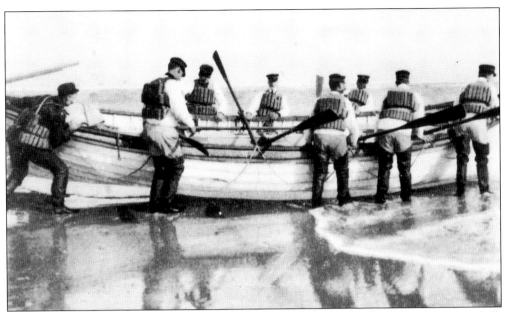

In 1906, this gallant life-saving crew prepares to launch their lifeboat in a practice drill. Speed, daring, and teamwork are the keys to successful rescues. (From the Henry A.L. Brown Collection.)

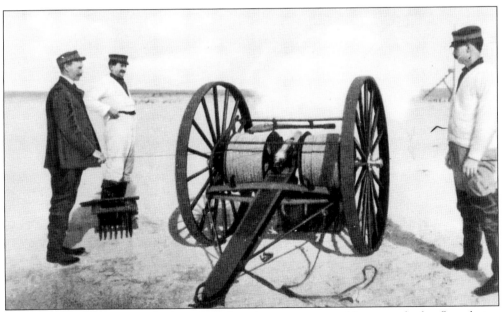

Many lives have been saved when the life-saving crews were able to reach the floundering vessels via the "Life Line." Once attached to the ship, a breeches buoy could be utilized to bring passengers and crew safely ashore. This photograph was taken *c.* 1906. (From the Henry A.L. Brown Collection.)

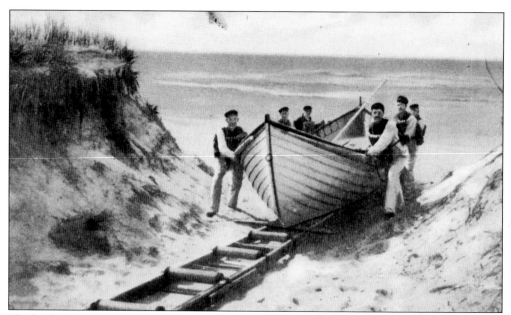

Block Island men have often received high praise for their life-saving efforts during the late 19th and early 20th centuries. Here, c. 1906, the crew returns with the lifeboat. (From the Henry A.L. Brown Collection.)

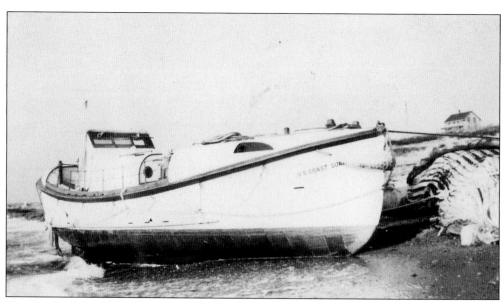

During the late 1930s, there was an embarrassing moment for the Coast Guard as their double-ender rescue boat broke its mooring and washed ashore. (From the Sandy L. Strickland Collection.)

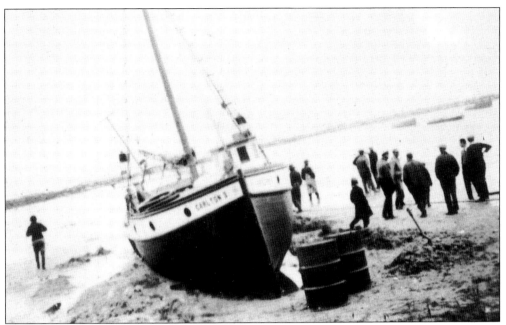

The waters off Block Island often show Mother Nature at her worst, as this grounded fishing boat, the *Carlton S.*, can attest *c.* 1930s. The island's shoals and occasional treacherous currents can make sailing around the island difficult. Unfortunately, maritime misadventures were familiar occurrences. (From the Sandy L. Strickland Collection.)

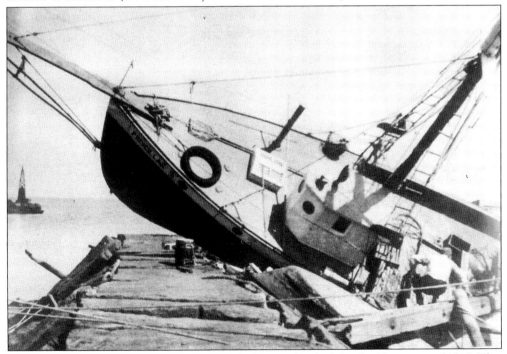

Many vessels such as the *Priscilla* were smashed upon the dock by the Hurricane of 1938. This storm, one of the worst to ever make its presence known on Block Island, virtually destroyed the fishing fleet. (From the Collection of Mrs. C.H. Lewis.)

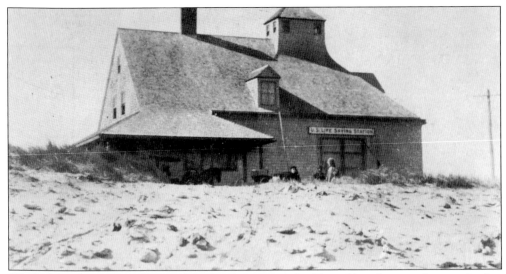

Word of the disastrous collision of the *Larchmont* and the *Harry Knowlton* was first received at the Sandy Point Life Saving Station on Block Island, February 11, 1907. (From the Henry A.L. Brown Collection.)

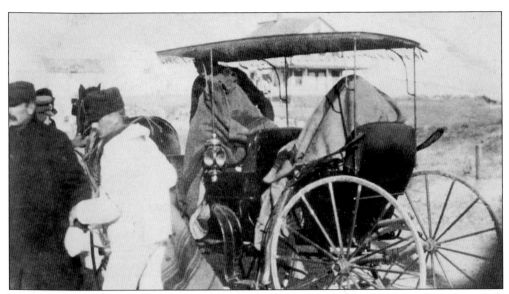

Those who survived the *Larchmont* sinking in 1907 were taken to the New Shoreham Life Saving Station. Once again, photographer H. Ladd Walford managed to capture the horror of the situation. (From the Henry A.L. Brown Collection.)

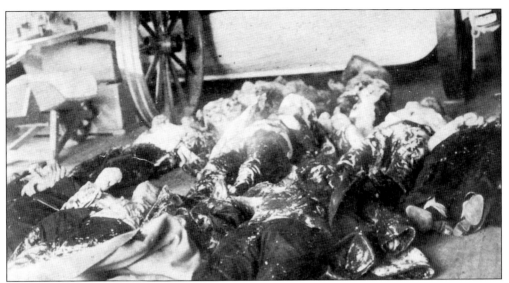

The *Larchmont* and the *Harry Knowlton* collided about 3.25 miles south-southeast of Watch Hill light in bitter cold (3 degrees) weather. These unfortunates were photographed at the New Shoreham Life Saving Station by H. Ladd Walford. (From the Henry A.L. Brown Collection.)

The crew on the schooner *Elsie* rescued eight of the survivors from the *Larchmont* in 1907. Its captain was John W. Smith and its crew consisted of Albert E. Smith, George E. Smith, Louis N. Smith, Earl A. Smith, Jeremiah Littlefield, and Edgar Littlefield. Historian Horace Belcher took this picture of the vessel in 1908. (From the Henry A.L. Brown Collection.)

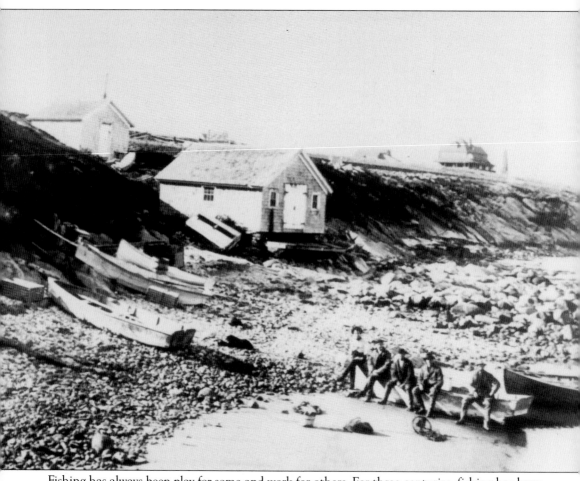

Fishing has always been play for some and work for others. For three centuries, fishing has been the main occupation of many Block Islanders. One of the attractions for the early settlers was the large number of cod in the waters around the island. Cod, blue-fish, tautog, and swordfish were main incentives for fishermen to come to the island in the 19th and 20th centuries. This photograph was taken *c.* 1912. (From The Henry A.L. Brown Collection.)

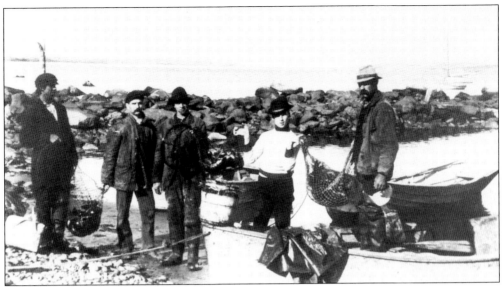

Early 20th-century lobster fishermen, with their catch at the Old Harbor break-wall, *c.* 1912, enjoy the benefits of the sea. The waters off Block Island, just 10 miles from the Rhode Island mainland and 18 miles from Montauk Point, have proved to be an ideal setting to catch tuna, marlin, and swordfish, as well as lobster. (From The Henry A.L. Brown (G.K. Page) Collection.)

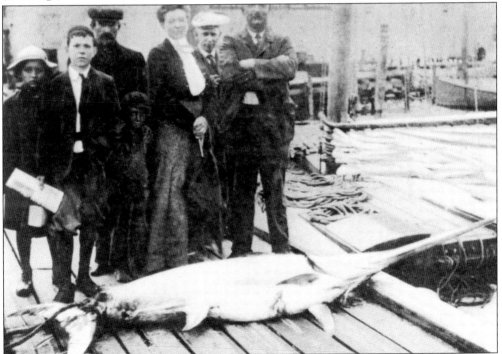

While the women and young children enjoyed pleasant days at the beach, the men would often indulge in the sport of deep-sea fishing. When there was a catch, such as this swordfish in 1906, all were expected to come to admire the accomplishment of the "head of the household." (From the Henry A.L. Brown Collection.)

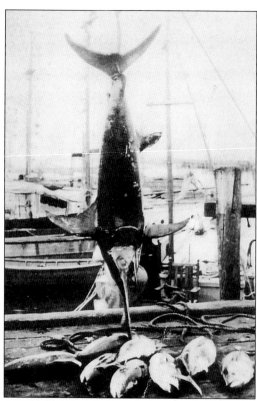

This magnificent swordfish was caught off Block Island in 1930. Swordfishing was especially good in July. Boats left at four or five a.m., often with as many who came along to watch as those who were able to harpoon the mighty fish. (From the Henry A.L. Brown Collection.)

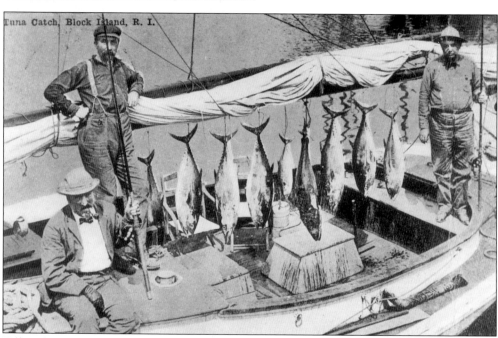

Yellow fin tuna were in abundance in 1921, as is evident in this photograph. Unfortunately, the tuna population has been sharply decreased by "over-fishing." (From the Henry A.L. Brown Collection.)

70

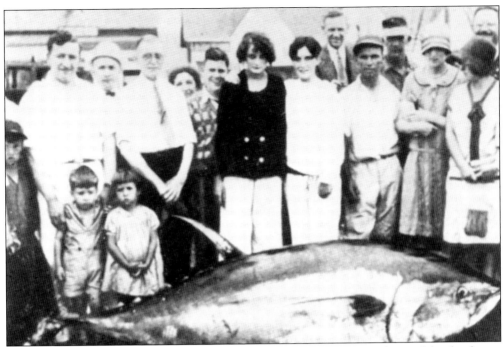

What became of this 400-pound tuna that was landed in 1930? Was it destined for the dinner table or the dump? During this period, tuna were not highly prized, but sought after more for sport than profit. (From the Henry A.L. Brown Collection.)

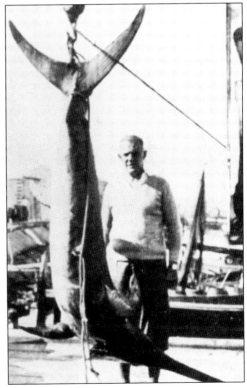

This 1930s sports fisherman has harpooned a mighty swordfish and proudly displays it at Old Harbor. (From the Henry A.L. Brown Collection.)

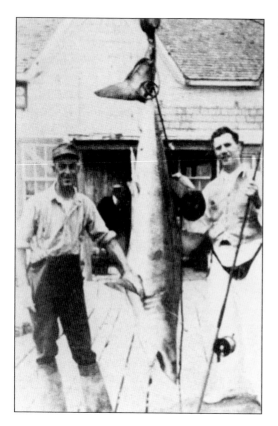

Fishing adventure is shown here at its best, with the rod and reel capture of a mako shark in 1930. (From the Henry A.L. Brown Collection.)

Lester (Shorty) Littlefield caught his stupendous 45-pound "striper" off Block Island in 1957. The sea can be both kind and cruel. It is kind when it provides a living for the islanders through fishing, both for sport and commercially. (From the Sandy L. Strickland Collection.)

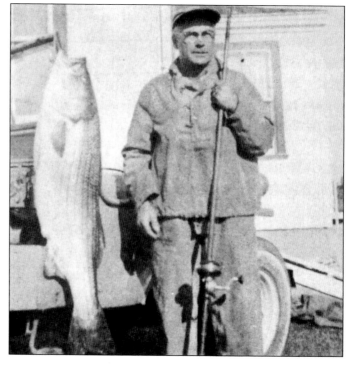

Four

NEW HARBOR

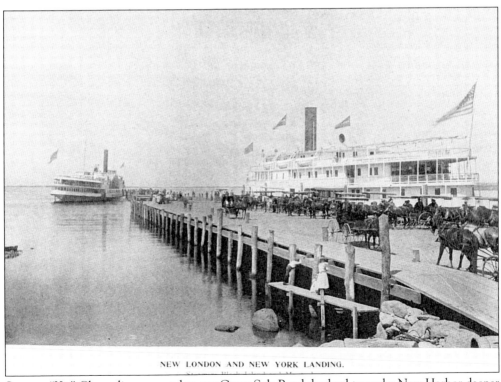

NEW LONDON AND NEW YORK LANDING.

Senator "Kit" Champlin managed to get Great Salt Pond dredged to make New Harbor deeper than Old Harbor. With the coming of the large vessels to this port, his hotel, New Hygeia, prospered greatly. The pond is seen here, c. 1915. (From the Henry A.L. Brown Collection.)

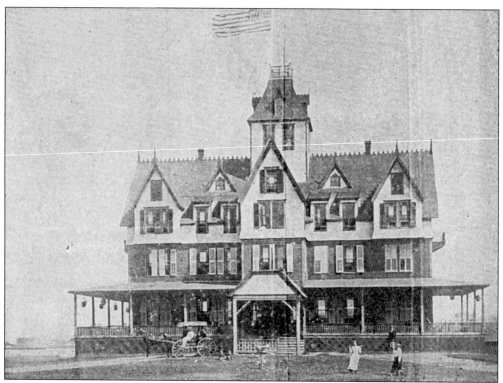

Christopher Elihu (Kit) Champlin, a "Brayton Democrat" and political activist on the island, owned the famous Hygeia Hotel on the Great Salt Pond. Thanks to "Boss" Brayton and Senator Nelson W. Aldrich, federal money was obtained to dredge the pond and create New Harbor. The hotel is shown here *c.* 1894–96, shortly before the harbor came into being. (From the Henry A.L. Brown Collection.)

In 1894, long before the invention of sun-blocking products, ladies at the dock in New Harbor used parasols for protection from the sun. (From the Henry A.L. Brown Collection.)

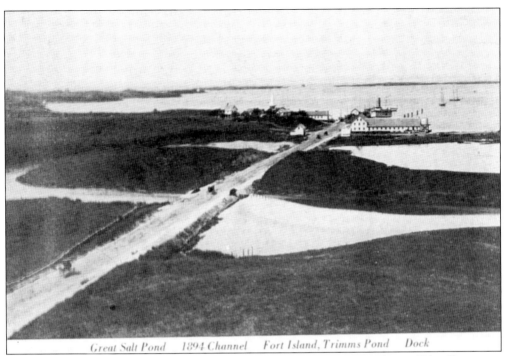

Great Salt Pond 1894 Channel Fort Island, Trimms Pond Dock

Great Salt Pond practically divides the island into two sections. As early as 1730, efforts were made by the settlers to build a harbor on the large pond, but all efforts failed until 1897. (From Ethel Colt Ritchie's *Lore & Legends*, 1955.)

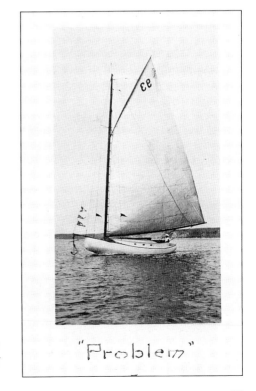

"Problem"

Block Island was visited by many fine sailing vessels over its long history. One of the most impressive was the *Problem*, a frequent visitor to the island in 1914. Warwick shipyard owner Frank Pettis had no difficulty in recognizing the *Problem* as a Pawtuxet catboat. (From the Henry A.L. Brown Collection.)

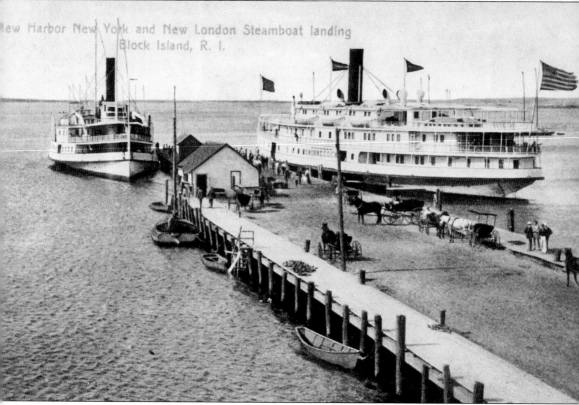

ew Harbor New York and New London Steamboat landing
Block Island, R. I.

Steamer *Canonicus* ran often from Providence to Block Island's New Harbor. Block Islanders have remained faithful to the history of the state as many native names are used to remind us of the island's early heritage. This vessel was named for Canonicus, the chief sachem of the Narragansett, who befriended Roger Williams in 1636. The large steamer *Shinnecock* is also seen here at the dock. (From the Henry A.L. Brown Collection.)

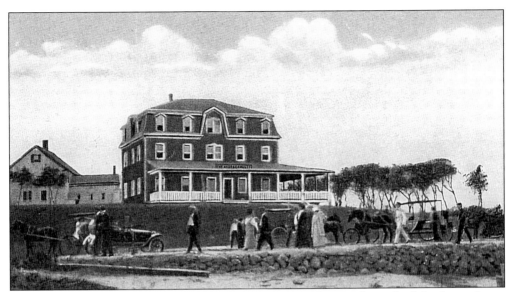

The traffic in front of the Narragansett Hotel in 1922 depicts the end of the horse-drawn carriage era. Soon, these vehicles made way for the horse-less carriage. (From the Henry A.L. Brown Collection.)

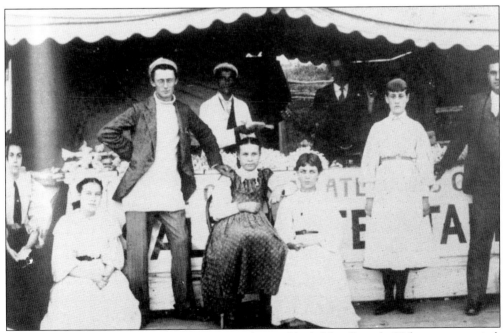

Everyone was familiar with the "Taffy Tent" during Block Island's early 20th-century period. Noel Mitchell, the man in the apron, first produced salt-water taffy on Block Island. Later, he became the mayor of St. Petersburg, Florida, and is credited with introducing the famous "green benches," so popular with senior citizens, to the Florida city. (From the *Block Island Scrapbook* by Maizie, 1957.)

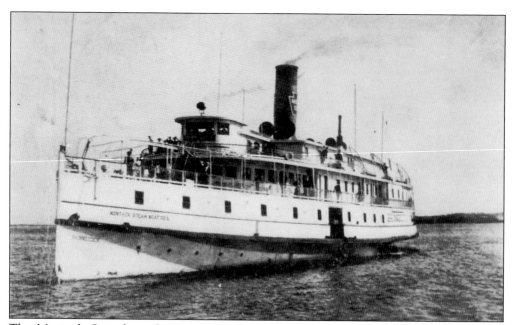

The Montauk Steamboat Company ran the steamer *Shinnecock* from New York to Block Island. The famous ferry is shown coming into New Harbor in 1917. (From the Henry A.L. Brown Collection.)

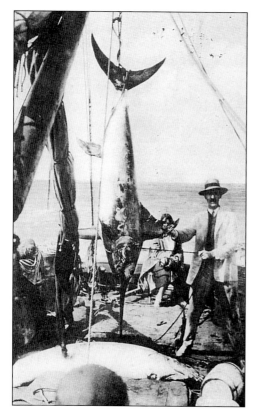

Even at the height of the Depression, New Yorkers fortunate enough to be able to escape the heat of the city came to Block Island to relax and perhaps to capture the broad bill swordfish (c. 1935). No one can explain the lure of harpooning the big fish, but it certainly has had its devotees over the years. (From the Henry A.L. Brown Collection.)

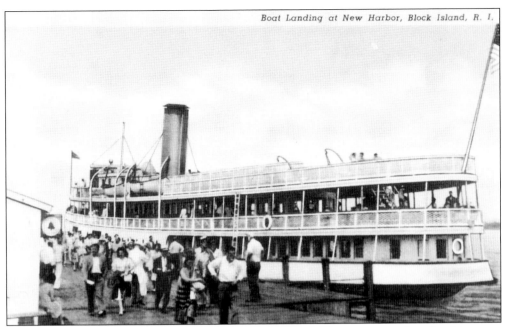

New Harbor boat landing is crowded with "day-trippers." They came to the island in great numbers in the 1950s and the stream has continued ever since, swelling the island's population in the summer months. (From the Henry A.L. Brown Collection.)

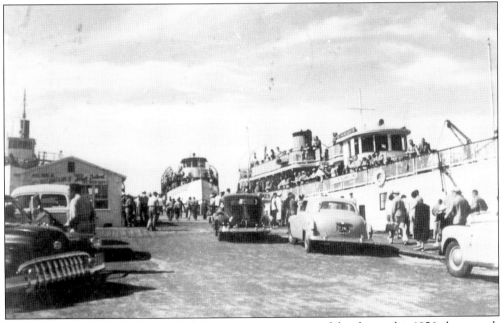

New Harbor is also a major port for bringing in passengers and freight, as this 1956 photograph indicates. (From the Henry A.L. Brown Collection.)

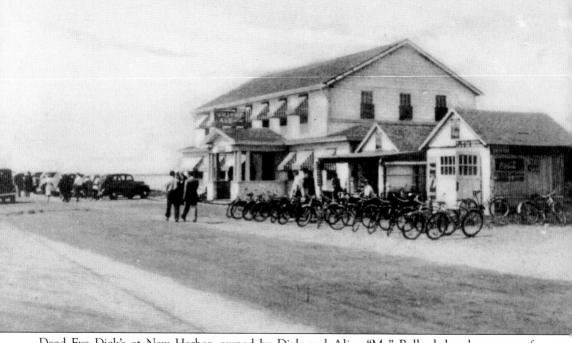

Dead Eye Dick's at New Harbor, owned by Dick and Alice "Ma" Ballard, has been one of the island's popular "watering" spots during the late 20th century. (From the Henry A.L. Brown Collection.)

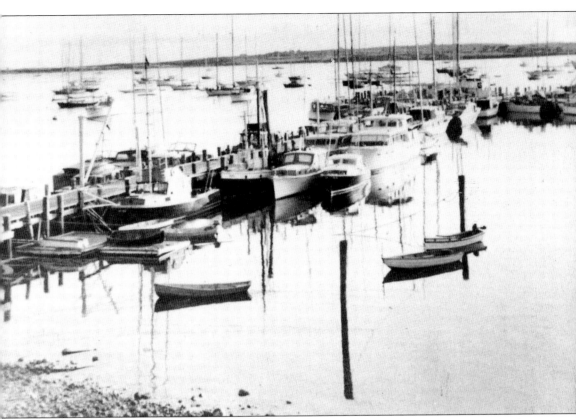

The Great Salt Pond with Champlin's Dock in the foreground became a common scene by the turn of the century. Christopher Elihu (Kit) Champlin, Block Island's senator in the 1890s, was the prime mover in getting the Great Salt Pond dredged so that New Harbor could be created. (From F.S. Blanchard.)

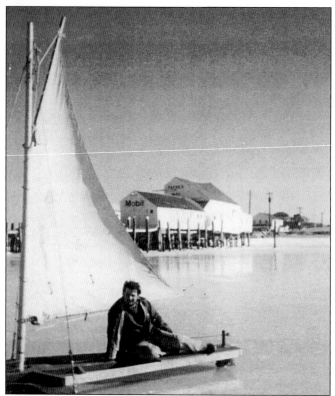

In 1974, Block Island witnessed one of its coldest winters ever. Councilman Nicholas De Petrillo, proprietor of Nick's Tavern, took advantage of the day and went ice-boating on salt ice at New Harbor. (From the Nicholas De Petrillo Collection.)

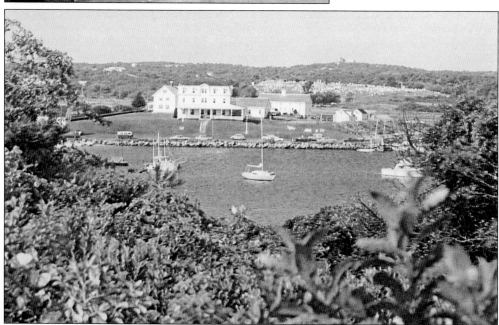

Narragansett Inn and cottage owed its origin to Samuel D. Mott Jr., who first operated a dinner hall here in 1896. It was called the Lake Shore Dining Hall. The hotel was opened in 1912 and has been one of the island's attractions for many decades. (From the Henry A.L. Brown Collection.)

Five

THE WEST SIDE
AND THE CENTER

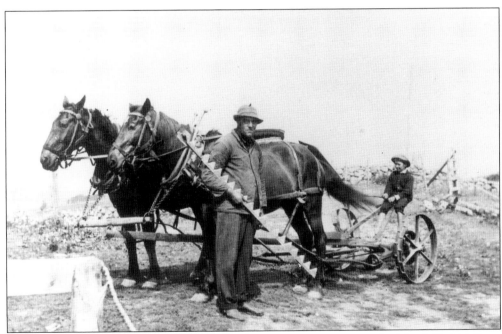

During the early 20th century, farming was the major occupation on the island. Ezebiel Rose, son of Peggy and Caleb Rose, is displaying his newly sharpened sickle-bar in preparation for cutting hay on Block Island in 1916. Note the barefoot boy, with cheeks of tan, holding the reins. (From the Henry A.L. Brown Collection.)

Mrs. Caleb (Peggy) Rose is seen here at her home on the west side of the island, adjacent to the windmill. Note Mrs. Rose's hands. As is the case for so many elderly islanders, arthritis wreaked havoc with her limbs. (Courtesy of her great-granddaughter, A. Mabel Smith.)

Elizabeth Dickens Smith, an elderly Block Island resident, looks out at the countryside from the doorway of her ancient dwelling, c. 1912. (From the Henry A.L. Brown Collection.)

During the early 20th century, those who lived on the island formed a tightly knit community and knew of their neighbors' joy and sadness. All knew when, in 1916, young Annabel Smith, seen here near her house on Dory Cove, and Bill Lewis Cooper began courting. In 1919, Annabel became Mrs. Bill Lewis Cooper. (From the Henry A.L. Brown Collection.)

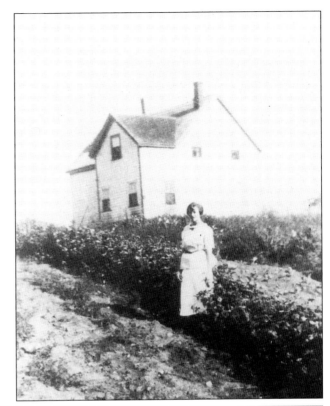

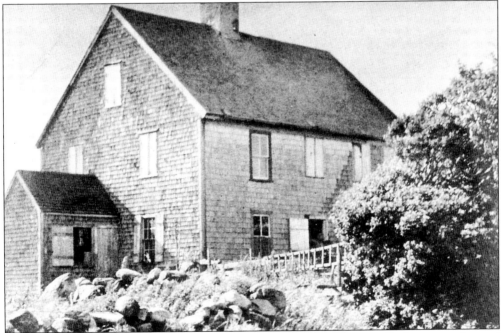

A very necessary part of any agricultural community was the gristmill that ground cereal grains into flour. This old structure at Mill Pond served that purpose. (From the Henry A.L. Brown Collection.)

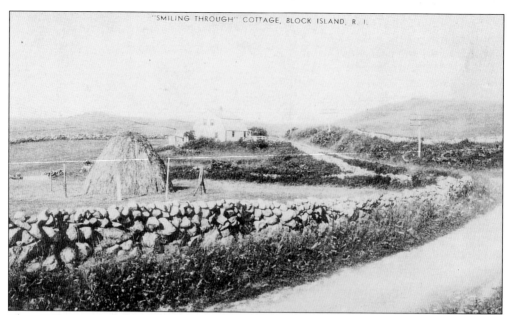

One of Block Island's many tourist attractions is the "Smilin' Through" cottage, seen in this c. 1938 photograph. It was the home of Arthur Penn, who wrote the popular song by the same name. In the 1950s, Mrs. Sally Mazzur tore down the 300-year-old house and replaced it with a very similar gambrel-roofed structure. (From the Henry A.L. Brown Collection.)

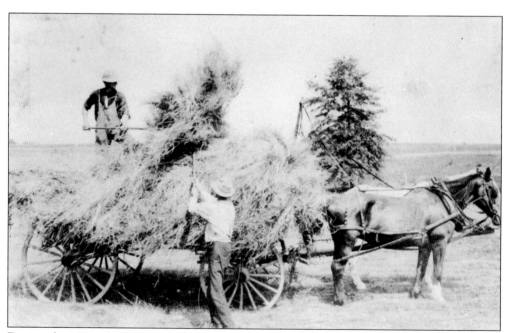

During the 1930s, haying, as well as many other Block Island activities, was still conducted in the old-fashioned way—with pitchforks and horse-drawn carts. (From the Henry A.L. Brown Collection.)

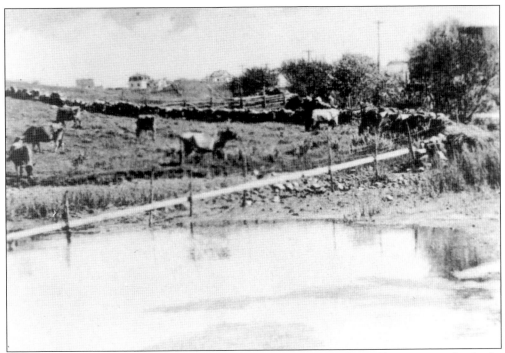

From as early as the late 17th century, islanders have found excellent pasture lands for their herds. The farms are divided by stone walls. Island history tells us that there were over 400 miles of walls built by African-American slaves in the 1700s. (From the Henry A.L. Brown Collection.)

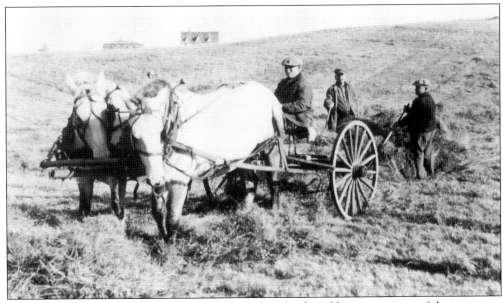

Farming, as well as fishing, was a part of life on the island, and haying was one of the necessary fall chores. Henry Littlefield is driving the horses in November 1940, while Joe Hull and Dol (Adolphus) Mitchell follow along. (From the Sandy L. Strickland Collection.)

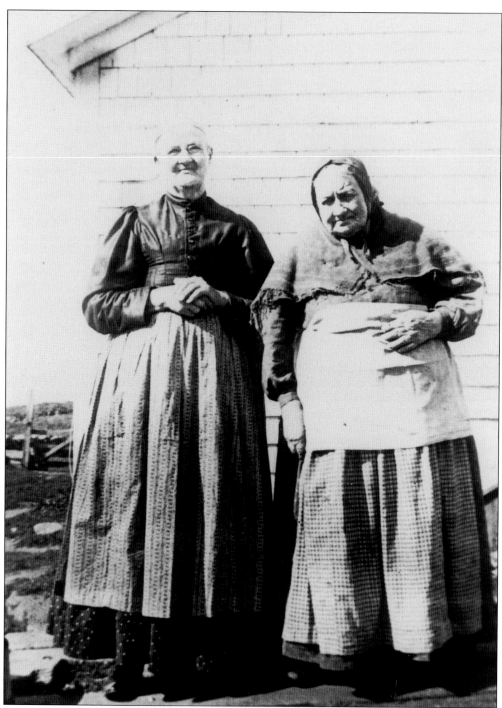

Two very well-known Block Islanders, Rosan Dickens Allen and Elizabeth Dickens Smith, are seen here at home near the Coast Guard Station on the west side of the island. Elizabeth's husband, Benjamin, was killed in the Civil War and buried at Arlington National Cemetery. Rosan met a tragic end when her petticoat caught fire while she was standing too close to the hearth. (From the Henry A.L. Brown Collection.)

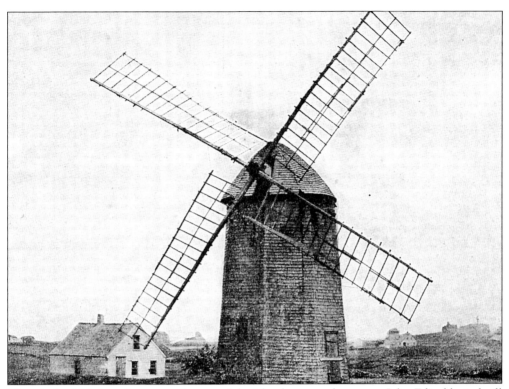

The wind, which is an important feature of the island, was used to power John Ed's old windmill not far from Old Harbor, c. 1900. The mill's sails moved the old grinding stone to make flour. (From the Sandy L. Strickland Collection.)

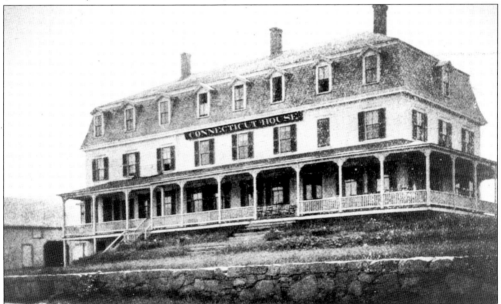

In 1889, the Connecticut House was owned by M.M. Day. It advertised that it was "especially adapted to those seeking rest and quiet . . ." It also promised to have a carriage waiting at the dock. (From the Henry A.L. Brown Collection.)

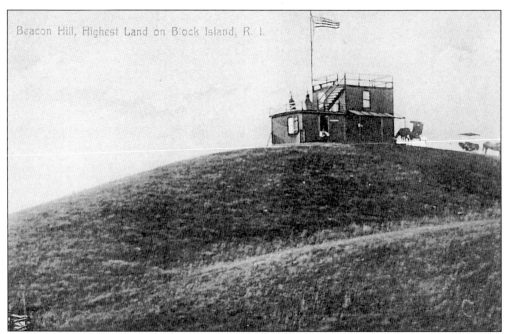

From earliest times, Beacon Hill was used by the settlers to give warning of danger. The old wooden tower on Beacon Hill was built in 1890 as a tourist attraction. Beacon Hill is 21 feet above sea level and is the highest and windiest spot on the island. (From the Henry A.L. Brown Collection.)

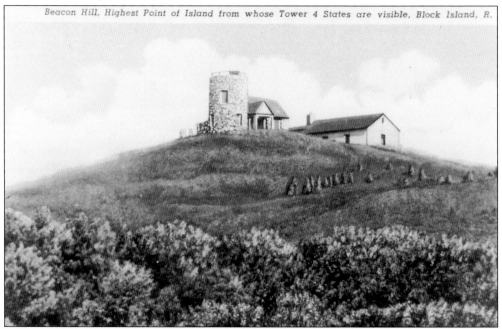

Beacon Hill, Highest Point of Island from whose Tower 4 States are visible, Block Island, R.

William H. Doggett, owner of Beacon Hill, built the Beacon Hill Stone Tower in 1928. Yankee stone mason David Sherman constructed the tower using only inclined planks, a trowel, a pry bar, and a plumb line. On a clear day, one can see the shores of Connecticut, Rhode Island, and Long Island. (From the Henry A.L. Brown Collection.)

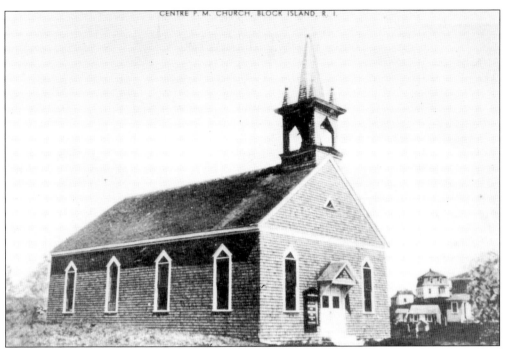

The charm of the Centre P.M. Church, built in 1907, has been greatly appreciated by worshippers throughout the years. John F. Hayes was the contractor of this simple, end-gable-roof building. (From the Henry A.L. Brown Collection.)

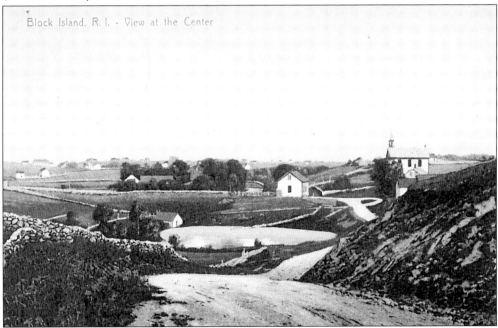

Block Island, R. I. - View at the Center

The view at the Center, c. 1900, shows the old town hall, which was originally a district #4 schoolhouse, as well as the Free Will Baptist Church. The original meetinghouse burned in 1869; in 1870, it was replaced by this church. In 1919, fire also claimed this building. (From the Henry A.L. Brown Collection.)

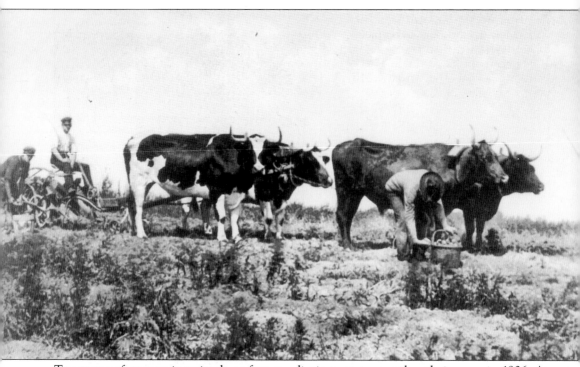

Two teams of oxen wait patiently as farmers, digging potatoes, gather their crops in 1906. At that time in Block Island history about two-thirds of the inhabitants were farmers. There were about 400 farms, many of them with considerable numbers of sheep and cows. Note the boy, with switch in hand, leading the oxen. (From the Henry A.L. Brown Collection.)

The Fresh Pond site is one of the most historically significant areas on Block Island. It was here that the original settlers lived in caves in 1661. It is also the site of the first church in 1772. (From the Don D'Amato Collection.)

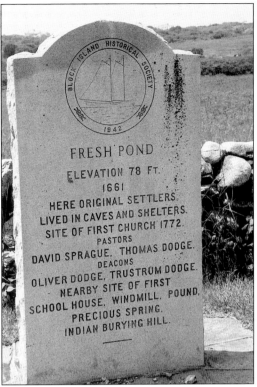

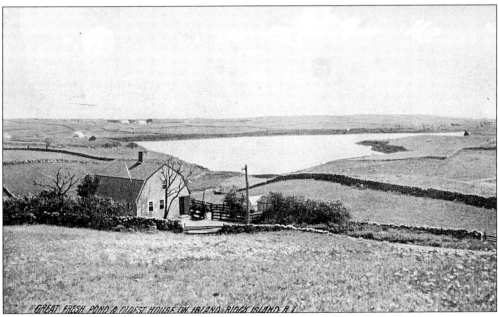

The oldest house on the island, c. 1903, was located on the Great Fresh Pond, which covers 1,000 acres. The house was probably built by John Alcock in 1691 and was known as "Smilin' Through" in the 1920s. Block Island is reported to have 365 ponds—one for every day of the year. Eighty-five are "permanent ponds" and many are spring fed. (From the Henry A.L. Brown Collection.)

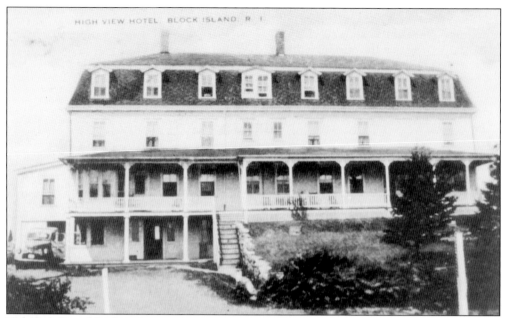

The High View Hotel on Connecticut Avenue is seen here at about the time, c. 1954, that Block Island was re-discovered by those looking for the "perfect summer vacation." (From the Henry A.L. Brown Collection.)

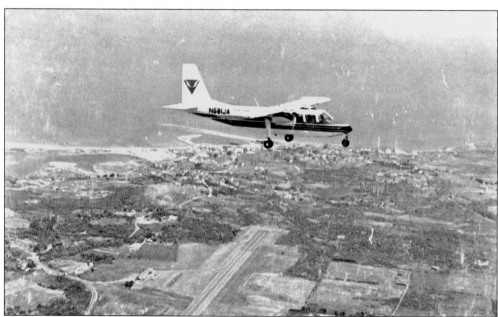

At one time, the only way to get to Block Island was by a sailing vessel, then later by steamer. Now, a trip to the island getaway is made easy by a short plane ride from Westerly. This new *Britten-Norman ISLANDER* plane seats ten and carries a ton of cargo. The airport, completed in 1950, is situated on a 100-foot-high plateau at the island's center. (From the Henry A.L. Brown Collection.)

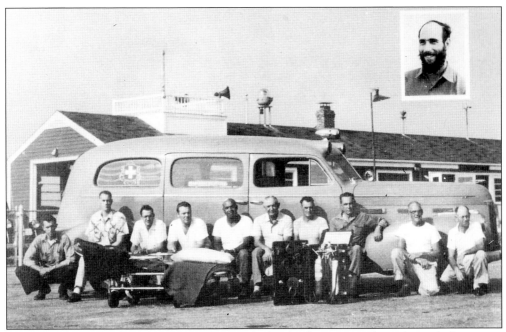

In 1950, the rescue squad assembled at the Block Island Airport, where the ambulance was housed before the erection of the police-fire center. Shown here are, from left to right, Edward Blane, John Aubrey, Walter Littlefield, Linwood Wright, Captain Frederick J. Benson, El Calder, Shirley Smith, Joseph Pennington, William Morris, and Fire Chief John C. Dodge. In the insert is Kevin J. Jones, who was the rescue squad captain in 1975. (From the 1975 50th Anniversary Celebration Program of the Block Island Volunteer Fire Department.)

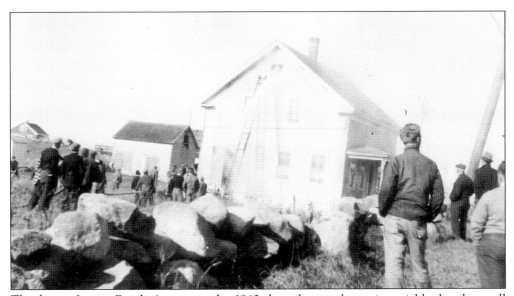

This house fire on Beach Avenue in the 1940s brought out the entire neighborhood as well as the firefighters. The fire department, organized in 1925, was quick to respond to the alarm. (From the Sandy L. Strickland Collection.)

Building, fixing, and repairing are all part of owning property on Block Island. Frank Mitchell, an "on-islander," can attest to this as he worked on a new house adjacent to the island cemetery in July 1970. (From the Henry A.L. Brown Collection.)

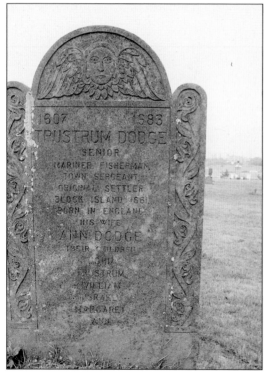

The beautifully carved gravestone designates the final resting place of Trustrum Dodge, one of the original settlers who came to Block Island in 1661. His descendants, especially noted for their exploits on the seas, have been among Block Island's most illustrious citizens. (From the Don D'Amato Collection.)

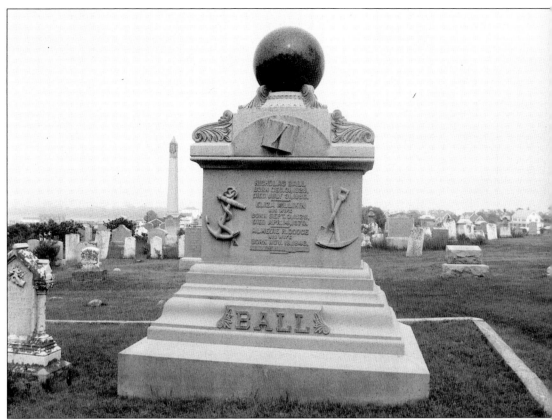

The handsome monument in the Block Island cemetery makes it obvious that Nicholas Ball was one of the island's most influential and affluent citizens. Ball, who had achieved fame and fortune in the California gold fields, was the person most responsible for the building of Old Harbor. Some of the oldest graves in the cemetery are marked merely by boulders. The oldest inscription is that of Margret Gutry, dated April 5, 1687. (From the Don D'Amato Collection.)

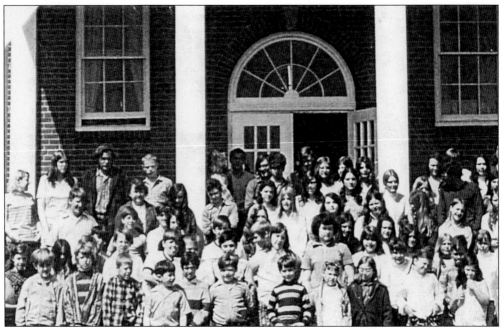

The first Block Island school was opened in 1875 to take care of the needs of the islanders who wanted to improve their skills. Reports compared the school favorably to others in Rhode Island. This is the Block Island School in 1974. (From the Henry A.L. Brown Collection.)

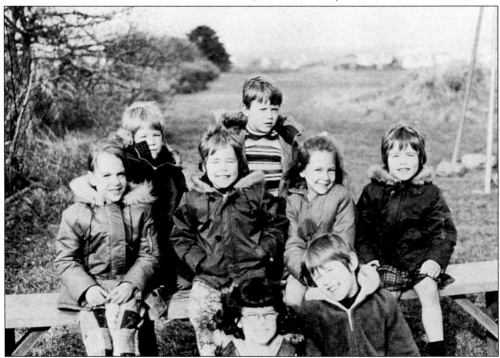

The Block Island School, with all grades under one roof, has been praised on many occasions. In 1980, these proud scholars, ranging in age from kindergarten to grade 12, take a break from their studies to pose for the photographer. (From the Henry A.L. Brown Collection.)

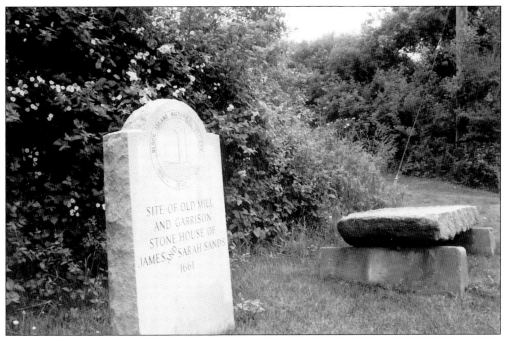

A well-carved and preserved marker of the Block Island Historical Society informs historically minded visitors of the site where James and Sarah Sands had their "mill and garrison stone house" in 1661. (From the Don D'Amato Collection.)

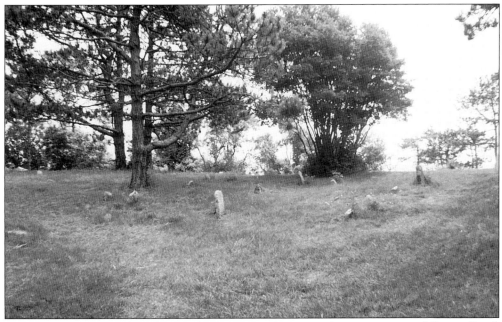

This Native-American burial ground is at Isaac's Corner at the intersection of Center Road, Lakeside Drive, and Cooneymus Road. The headstones are small fieldstones, which are closely set together. Native-American custom dictated that the dead should be buried in an upright position with a pot of clams or oysters beside them to help them on their voyage to the next life. (From the Don D'Amato Collection.)

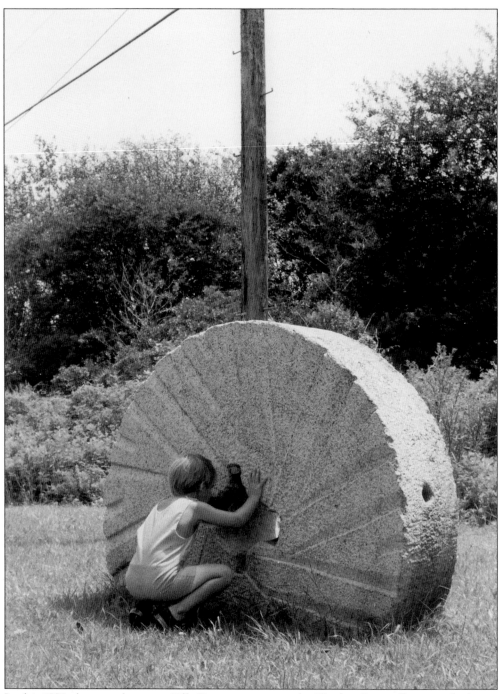

In this 1970 photograph, young Billy Brown poses near the "Scalper," or mill-stone, which was once in John Ed's mill. The stone is near the airport, close to the intersection of Old Town and Center Roads. (From the Henry A.L. Brown Collection.)

Six

THE SOUTHERN SECTION

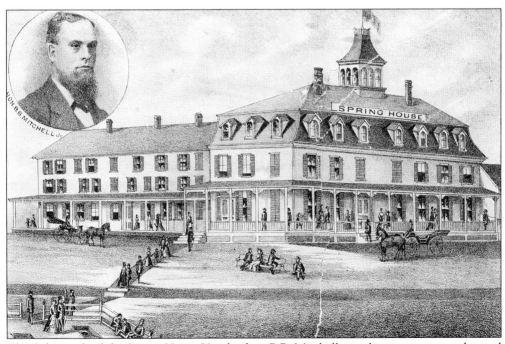

This lithograph of the Spring House Hotel, when B.B. Mitchell was the proprietor, emphasized the magnificent Victorian edifice that attracted guests from New England and New York. (From the Henry A.L. Brown Collection.)

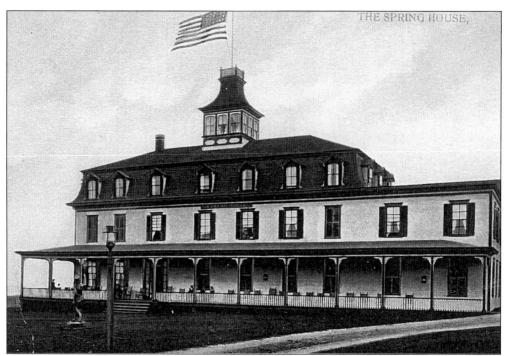

In 1919, when this postcard was mailed, the Spring House Hotel, sometimes called "the jewel of Block Island," was owned by the Payne family. The hotel was later owned by Sam Mott and his sisters, Mrs. Gill and Mrs. Roundtree. Sam Mott and his son Douglas ran the hotel until 1987, when it was sold to Dean Street, Inc. (From the Henry A.L. Brown Collection.)

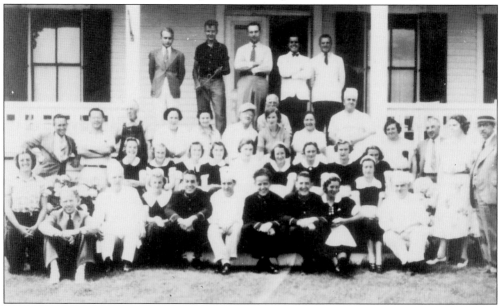

This handsome group brought the famous Spring House Hotel service to scores of happy guests assembled on the piazza in 1938. The hotel was named for the nearby springs. Over the years, such famous celebrities as Mark Twain, Billy Joel, and members of the Kennedy family have been guests at the Spring House Hotel. (From the Spring House Hotel Collection.)

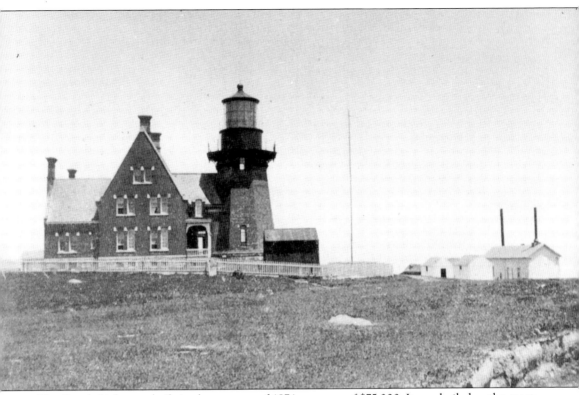

The South Light was built in the summer of 1874 at a cost of $75,000. It was hailed as the most beautiful lighthouse on the east coast and called "the sentinel of the sea." President U.S. Grant commissioned the lighthouse and had his picture taken with Henry W. Clark, the first keeper. In 1903, shortly before this picture was taken, the tug *Leyden*—despite the warnings from the light—foundered off the coast. The lighthouse keepers aided the Life-Saving Service in a heroic rescue and then gave the tug's crew shelter. (From the Henry A.L. Brown Collection.)

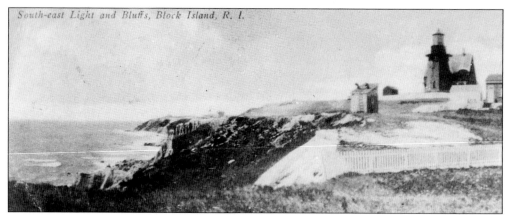

The South Light, at 204 feet above the sea, is one of the highest lighthouses on the New England coast. Thanks to the efforts of people such as Nicholas Ball, the lighthouse was erected in 1874. This early postcard captures it above Mohegan Bluffs in 1911. Erosion has removed 90 percent of the bluffs seen in this photograph. (From the Henry A.L. Brown Collection.)

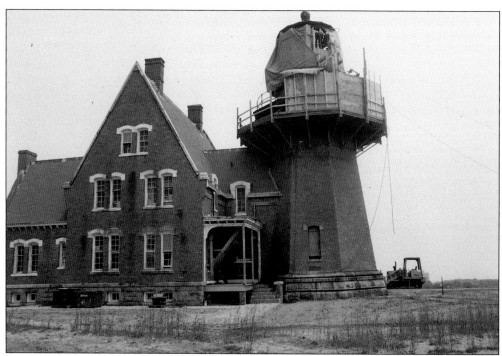

Due to the constant erosion, South Light had to be moved back from Mohegan Bluffs to protect it. In the spring of 1994, the work was under way. All Block Islanders, and hundreds of well wishers, contributed to the successful effort. With its 3-million-candlepower light, the beacon is visible up to 35 miles at sea. (From the Don D'Amato Collection.)

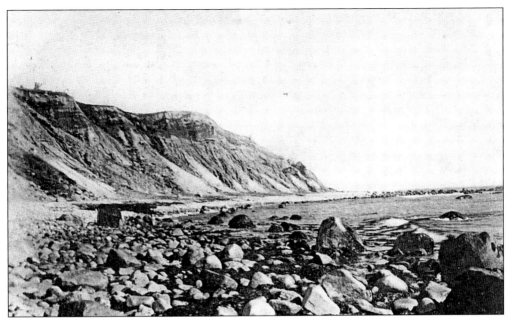

From its majestic vantage point over the bluffs, historic South Light provides a beacon for mariners off the shore of Block Island. Erosion has exposed multi-colored patterns of the soil structure, adding to its beauty. Many visitors, upon seeing the beauty of Mohegan Bluffs, have called Block Island "the Bermuda of the North." Island lore according to S.T. Livemore tells us that it was here, prior to 1635, that the Manisses Indians forced the invading Mohegans over the bluff. (From the Henry A.L. Brown Collection.)

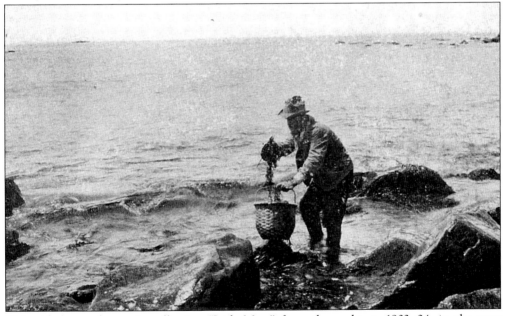

This elderly gentleman is collecting "Irish Moss" from the rocks, c. 1903–04, in the type of basket made on Block Island for that purpose. Many islanders still remember the "moss pudding" made by their parents during the Depression. (From the Henry A.L. Brown Collection.)

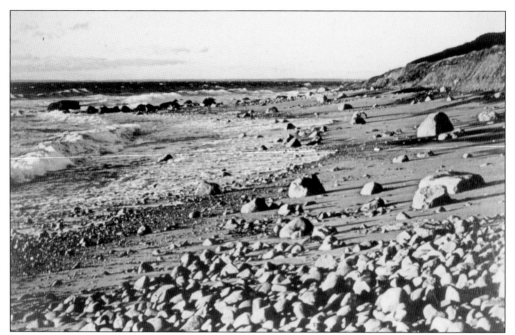

A late 20th-century view of a west-side beach makes it clear that the sea continues to rule along the shore of Block Island. Major storms, such as the Gale of 1815 and the Hurricane of 1938, have made significant changes in the pattern of the island's shore. (From the Henry A.L. Brown Collection.)

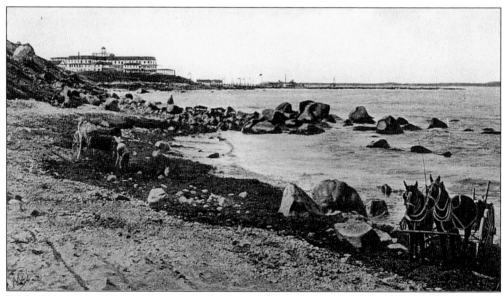

With the steamer *Mount Hope* in the background, farmers are gathering the seaweed that is so abundant after storms. Oxen usually were used to pull the carts, but in this view before the Ocean View Hotel, horses perform the task. (From the Henry A.L. Brown Collection.)

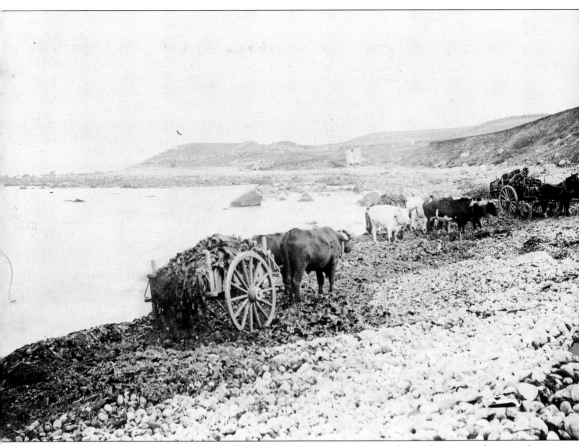

Gathering seaweed on "Pebbly" Beach in January 1908 was not without danger as the round, wet stones could be difficult. This was one of the reasons for the use of the oxen, which were more sure-footed than horses. (From the Henry A.L. Brown Collection.)

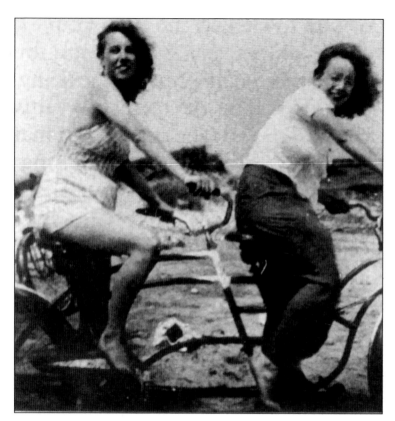

A beautiful day, a bicycle built for two, and Block Island is equal fun for Hope G. Knight and her sister, Cranston visitors to Block Island in 1940. (From the Henry A.L. Brown Collection.)

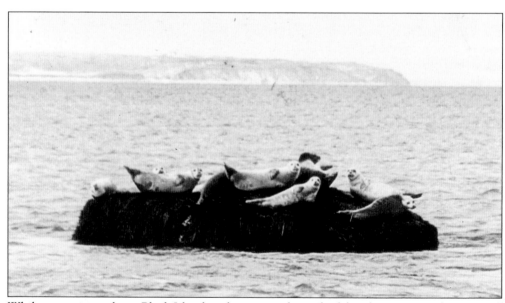

While most visitors leave Block Island in the winter, these playful seals come into the water off Clayhead, near Crescent Beach. (From the Henry A.L. Brown Collection.)

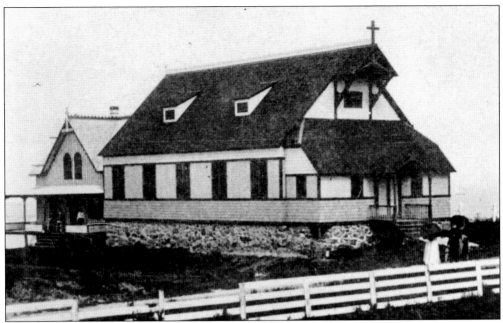

St. Anne's Episcopal Church in 1900, as shown in John F. Murphy's *Souvenir of Block Island*, 1904–08, was destroyed by the Hurricane of 1938. (From the Henry A.L. Brown Collection.)

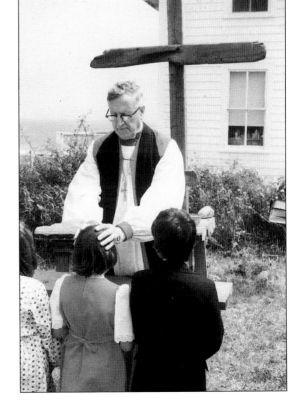

Episcopal Bishop Belden conducts a confirmation ceremony at the ruins of St. Anne's Church on Block Island in July 1978. The island, once almost totally inhabited by those of the Baptist persuasion, now has a broad religious base with a number of denominations represented. The children are Heather Gaffet and Daniel Brown. (From the Henry A.L. Brown Collection.)

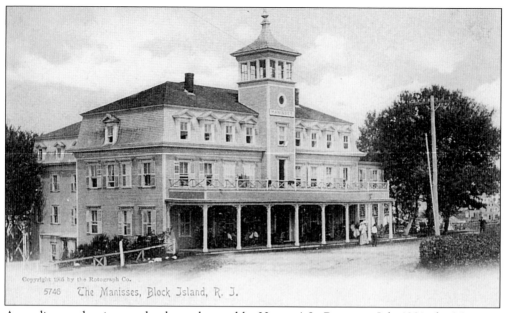

Copyright 1905 by the Rotograph Co.

5746 The Manisses, Block Island, R. J.

According to the sign on the door, observed by Henry A.L. Brown in July 1981, the Manisses Hotel was closed. It was given to the State of Rhode Island to be preserved for the Historical Society on Block Island. It has since been re-opened by Justin and Joan Abrams and is heralded as a place of fine dining and "a great spot for after dinner drinks and flaming coffees." (From the Henry A.L. Brown Collection.)

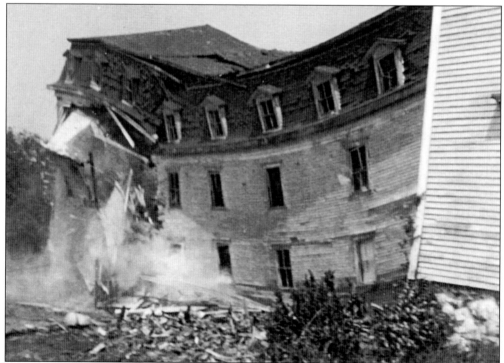

During July 1972, the Abrams family had the rear section of the Manisses Hotel demolished as it was on the verge of collapsing. The area has since been beautifully landscaped.

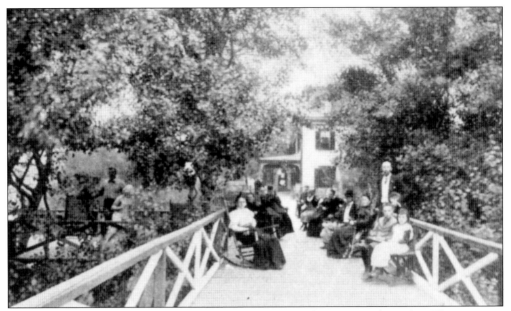

The Manisses Hotel, built in 1876, can be seen here from the Promenade Bridge. The rear wing seen in this picture was added in 1883; however, ravaged by time, wind, and weather, the wing was torn down in the 1970s. (From the Henry A.L. Brown Collection.)

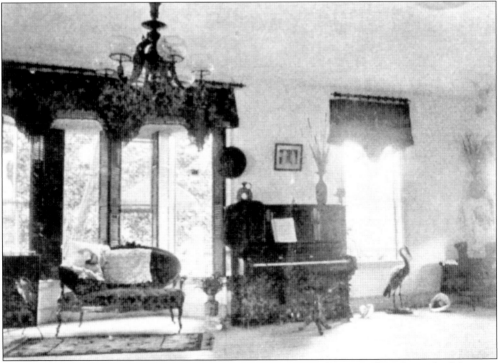

In addition to the very latest 19th-century innovations, such as inside toilets, the Manisses offered a music room, and on special occasions engaged an orchestra to play for the guests. This was the type of hotel that made Block Island so popular in the late 19th century. (From the Henry A.L. Brown Collection.)

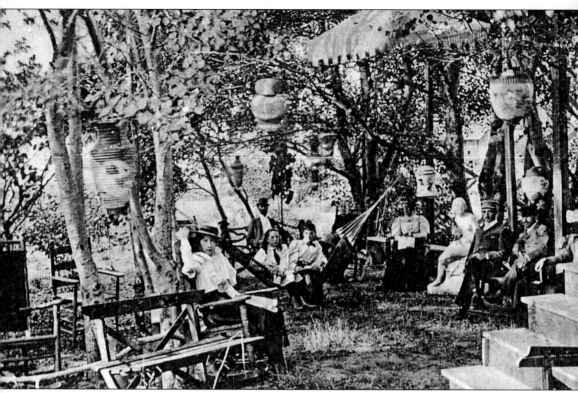

Summer visitors in the late 19th century are enjoying life in a shady spot on the Manisses grounds. This setting is lovely by day, and is turning into a romantic area at night, thanks to the use of lanterns. Lorenzo and Halsey C. Littlefield were the original owners and made the hotel a premier Block Island attraction. (From the Henry A.L. Brown Collection.)

Seven

LOOKING BACK

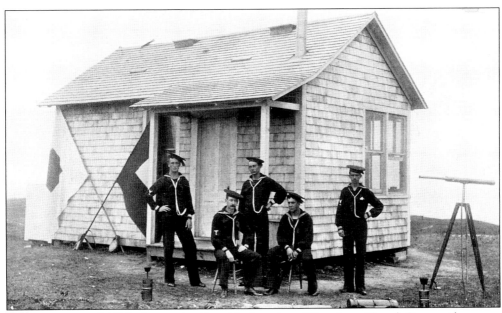

In the summer of 1898, during the Spanish-American War, these Signal Corps sailors were stationed on Block Island. The ranking member of this team, seen here in the center with a mustache, was William Henry Sykes. (From the Henry A.L. Brown Collection.)

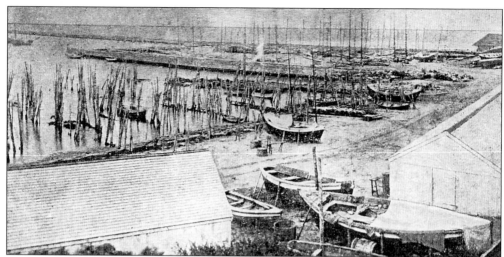

Pole Harbor at Block Island looked like this in the 1870s. The new break-wall had recently been completed, and Pole Harbor would be seen a relic of the past, as would the famous "cowshorn" or "double enders" that harbored there. (From the Henry A.L. Brown Collection.)

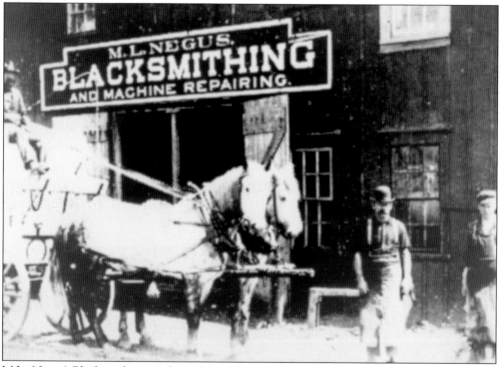

M.L. Negus' Blacksmithing and Machine Repairing establishment was of great importance during the horse-car era, as the equines required constant care and the blacksmith provided the shoes and other metal equipment needed. Their business rivaled in importance the modern garage of today. (From the *Block Island Scrapbook* by Maizie, 1957.)

The New London Steamboat Company enjoyed a brisk trade in the 1893 season, making six stops between Norwich, Connecticut, and Block Island. This broadside was made by the American Bank Note Company of New York, which also made the U.S. currency. (From the Henry A.L. Brown Collection.)

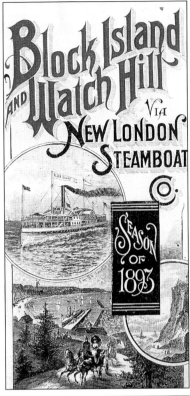

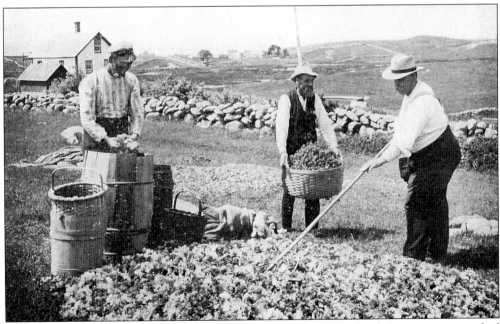

The curly "Irish Moss" was taken to a field and bleached, or dried. Later, it was cooked with sugar to make a pudding. The practice came from Ireland and the Scandinavian countries, where the pudding is still made today in some locales. (From the Henry A.L. Brown Collection.)

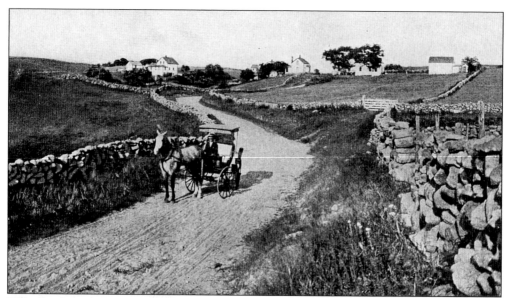

The island's once heavy growth of trees disappeared by the time of the American Revolution. In the valleys, however, large beds of peat were formed from vegetable matter washed down from the hillsides to the ponds. In this photo, early 20th-century islanders, c. 1916, enjoy a pleasant drive along daisy sprinkled meadows. (From the Henry A.L. Brown Collection.)

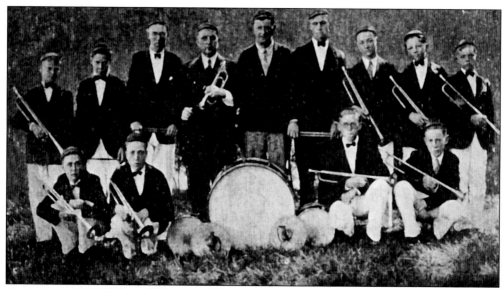

Fourteen and a half miles of ocean could not keep the "Music Man" away from Block Island as we see the instruments in the hands of the "Block Island Boys' Trumpet Band." (From the Henry A.L. Brown Collection.)

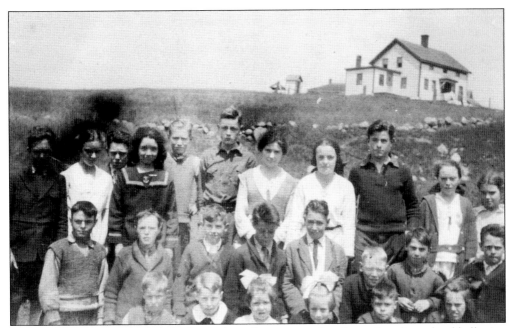

Most think of Block Island as the land of carefree summer fun, forgetting that school bells ring there from September until June as elsewhere. These handsome young scholars are grouped together in the early 1940s. (From the Sandy L. Strickland Collection.)

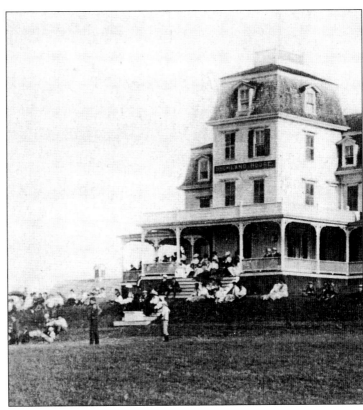

Ball players attract a crowd of spectators at the Highland House in 1906. There were many such activities and games for those who were not fishing or enjoying a day at the beach. (From the Henry A.L. Brown Collection.)

One of Block Island's colorful pilots, "Tal" Dodge was also one of the island's representatives to the general assembly. Dodge's exploits on the waters around the island and the bay have become legendary. His daring-do-inspired poetry appeared often in the newspapers around the turn of the century. (From *The Rhode Island Story*, David Patten, 1920.)

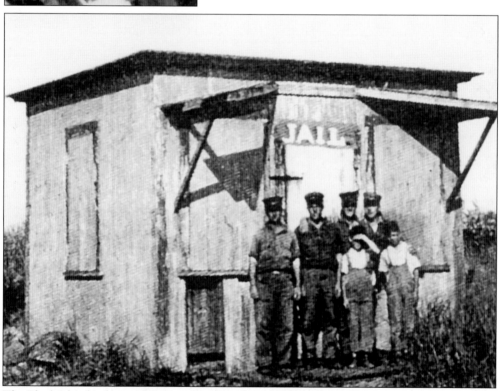

The Block Island jail, sans floorboards, was built in 1908 at a cost of $56. It was replaced in 1911 with the one depicted here. During the 1950s, when large numbers of visitors came to the island during the summer months, the Rhode Island State Police patrolled the area. (From the Henry A.L. Brown Collection.)

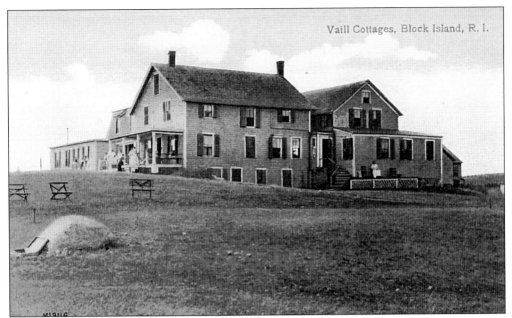

Vaill Cottages on South Bluffs were one-and-one-half-story shingle cottages built in 1885 by Dr. Abby E. Vaill of New York as part of a sanatorium complex. The hotel was added in 1893. It later served as a country club with the island's only golf course. The complex was demolished in the 1980s. (From the Henry A.L. Brown Collection.)

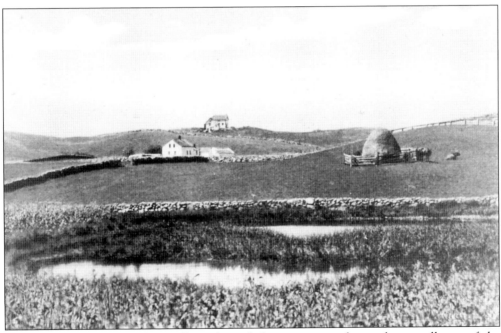

Rolling hills, pleasant fields, small ponds, and the ever-present haystack were all part of the early 20th-century charm of Block Island. Note the fence around the haystack to keep the cows from eating their winter forage. (From the Henry A.L. Brown Collection.)

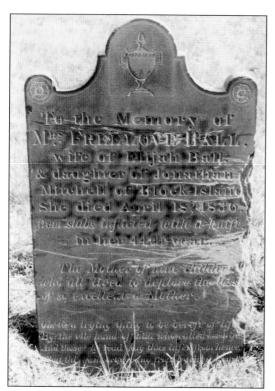

Block Island's Mrs. Freelove (Mitchell) Ball's gravestone can be found in the North Burial Ground in Providence. It was erected in 1830 by her children to remember "their worthy mother who was so cruelly killed" by her drunken husband. She died on April 18, 1830, in her 44th year "from stabs inflicted with a knife." (From the Henry A.L. Brown Collection.)

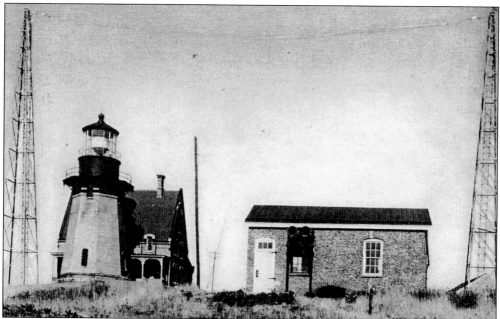

On August 9, 1904, the firm of Walter S. Massie, Engineers, installed the Wireless Telegraph Station and Towers, making it possible for the first transmission of messages from South Light, Block Island, to Point Judith on the mainland. The fog signal was activated by a 4-hp engine and the sound was made not by the wind but by steam going through a 17-foot trumpet. (From the Henry A.L. Brown Collection.)

The special knowledge and seamanship so many Block Islanders attained at a young age were much in demand during World War II. Capt. J.B. Lewis, son of Mary E.H. Lewis Rose (known as Maizie), was the youngest shipmaster in the Merchant Marines in 1943. (From the *Block Island Scrapbook* by Maizie, 1957.)

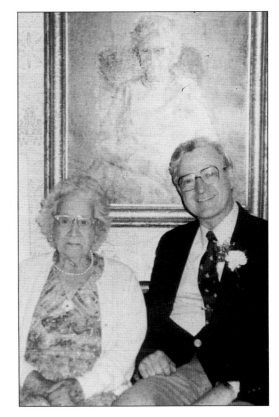

Miss Gladys Steadman, one of the founders of the Block Island Historical Society (1942), and former Governor Joseph Garrahy pass the time of day beneath her portrait at the Society's Woonsocket House in 1982. Miss Steadman, a small child living on the island at the time, remembers when the collision of the *Larchmont* and the *Harry Knowlton* occurred on February 11, 1907. (From the Nicholas De Petrillo Collection.)

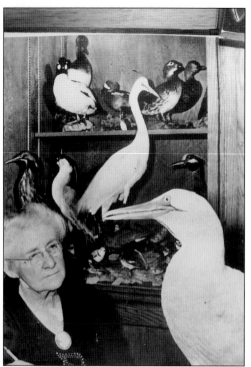

Miss Elizabeth Dickens's fame as an ornithologist spread far from her beloved Block Island. As the island is on the path of many migratory birds, Miss Dickens's daily record of bird sightings taken from 1909 until 1963 was invaluable to students of the subject. In addition, she inspired Block Island schoolchildren to take an interest in nature and conservation. (From the *Block Island Scrapbook* by Maizie, 1957.)

Seen here are Lillie Littlefield and her daughter, Vera Littlefield Sprague, in 1935. Vera was a victim of a tragic accident on the island in 1995. While she was pumping fuel near Old Harbor, a plane went out of control and crashed into the gas station, killing her. (From the Sandy L. Strickland Collection.)

"Beaten by billow and swept by breeze . . ." Block Island has been the perfect site for windmills. This modern version of the ancient power supplier continues to try to provide some of the necessary energy needed on the island, which has one of the highest electric rates in the U.S. (From the Don D'Amato Collection.)

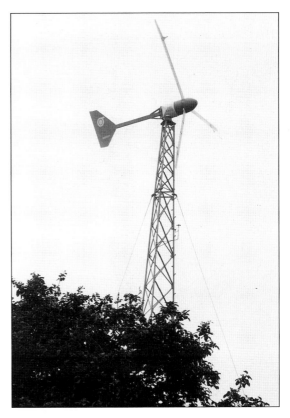

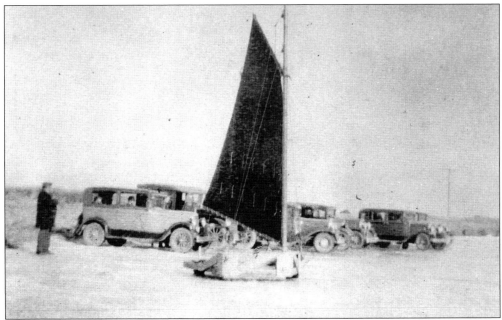

During the 1930s, "ice-boating" was a popular diversion on Block Island. Boats, such as the one shown here in 1932, would race across Sachem Pond on Corn Neck Road at speeds reaching 60 to 70 miles per hour. (From the Sandy L. Strickland Collection.)

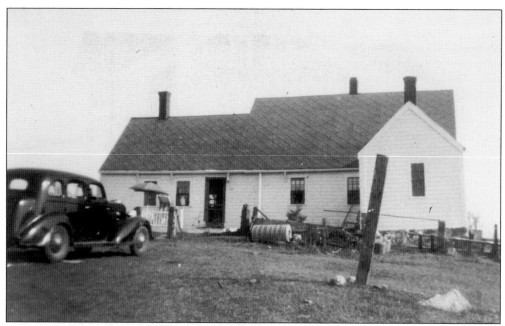

Dol and Madilene Mitchell lived in this sturdy house in the 1950s. Note the milk house on the south side. Many islanders raised much of their food and tried to be as self-sufficient as possible. (From the Sandy L. Strickland Collection.)

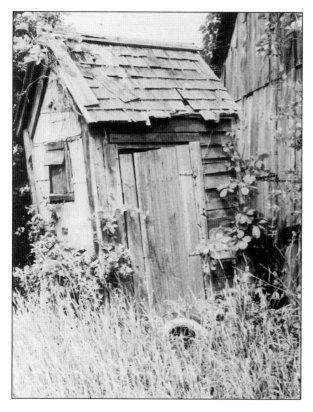

While many of the leading hotels boasted of inside plumbing in the late 19th century, the outhouse was still in common usage well into the 20th century. This one survived until 1970. (From the Henry A.L. Brown Collection.)

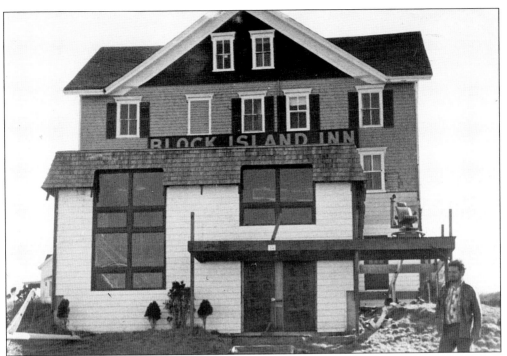

The Block Island Inn was under renovation in 1972. Nicholas De Petrillo, the proprietor, is one of the Block Islanders who believes that in preserving the past we serve the present. (From the Nicholas De Petrillo Collection.)

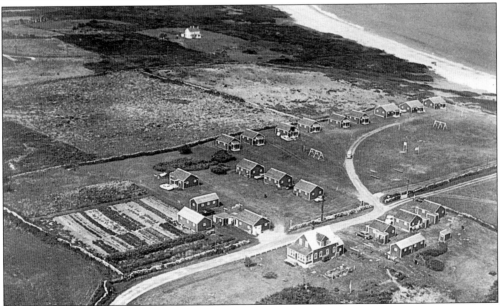

Photographer Frank Jo Raymond captured the Cutting Cottages off Corn Neck Road. The cottages, owned by Esther Cutting, offered furnished housekeeping units and a private beach. They were open from May to November. The picturesque buildings were all painted red and were visible from the incoming Block Island ferry. These houses have since been demolished, and "high-rise" units have replaced them. (From the Henry A.L. Brown Collection.)

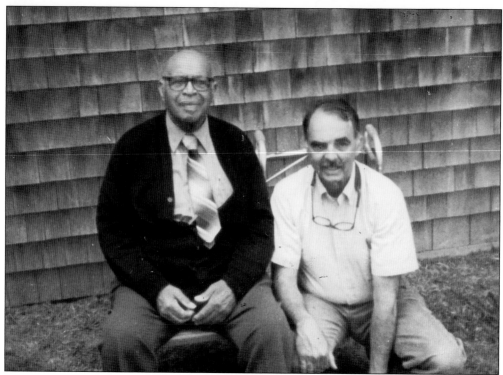

One of Block Island's most cherished citizens, Fred Benson, is joined by Henry A.L. Brown on August 15, 1985, at the Fred Benson picnic, scholarship award, and fund-raiser. (From the Henry A.L. Brown Collection.)

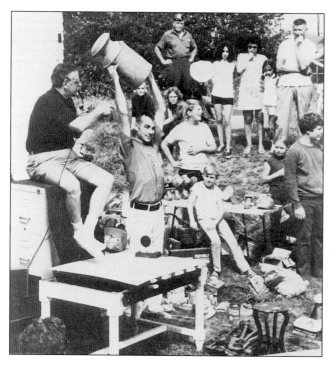

A successful auction took place on Block Island in August 1970. Auctions such as these were often used to raise funds for worthy causes. (Photographed by Klaus Gemming; from the Henry A.L. Brown Collection.)

This handsome crew is getting ready for a day at the beach. Shown here are, from left to right, Daniel H. Brown, Heather Brody, and William A.H. Brown. (From the Henry A.L. Brown Collection.)

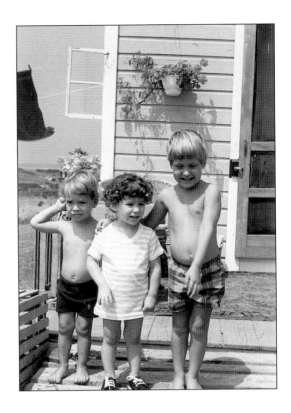

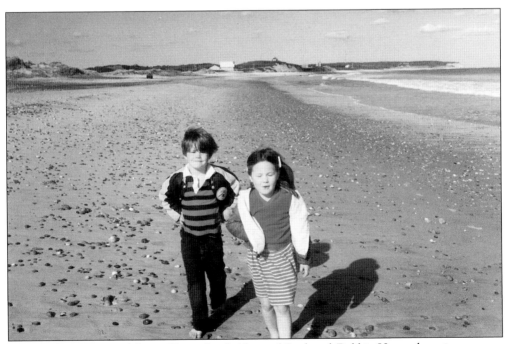

On-islanders Jason and Jessie Howarth, children of Fred and Debbie Howarth, enjoy a warm Columbus Day at Crescent Beach in 1980. (From the Henry A.L. Brown Collection.)

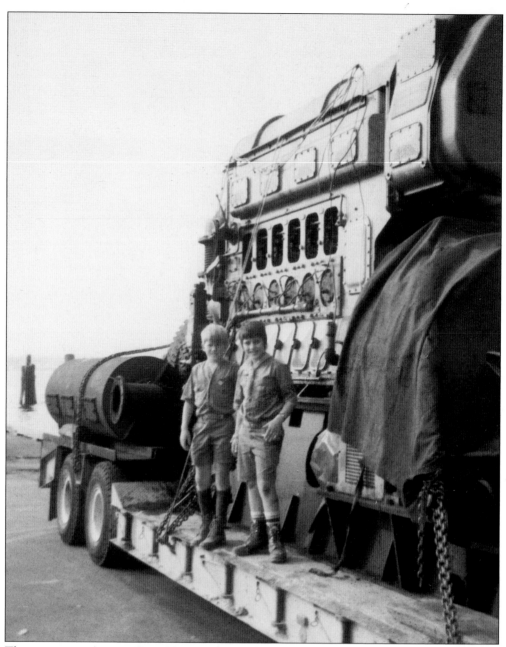

These two young scouts, Scott Heinz and Daniel H. Brown, couldn't resist the lure of the huge Electric Company Diesel Engine, in August of 1978. The engine was being shipped to Block Island from the Point Judith Ferry Landing for the power plant. Thanks to the machine, life on Block Island in both summer and winter has become much more pleasant. (From the Henry A.L. Brown Collection.)